Postcard History Series

Swannanoa Valley

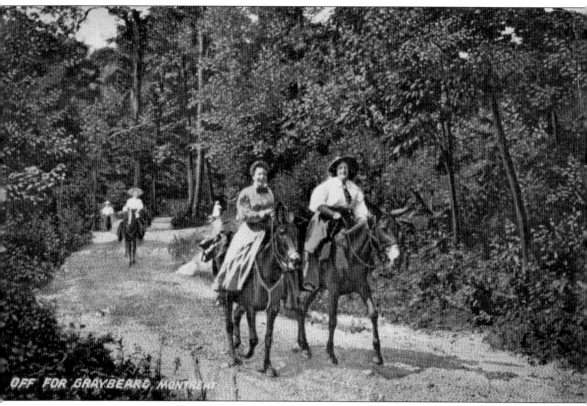

In 1898, Mary Miller of Bryn Mawr, Pennsylvania, came to the Swannanoa Valley for a short visit, seeking to recuperate from the strain of college and caring for her aging parents. Instead, she chose to stay for a lifetime, building a home, marrying, raising three children, and teaching in Montreat. In 1909, Miller (right) starts off for Graybeard Mountain. (Authors' collection.)

ON THE FRONT COVER: The arrival of train service to the Swannanoa Valley and Asheville in 1880 allowed easy access for tourists and commercial trade. Arriving by train from Asheville to the Black Mountain station was a common occurrence, with overnight accommodation provided at the old Gladstone Hotel. (Authors' collection.)

ON THE BACK COVER: Later used as a model for the overlooks on the Blue Ridge Parkway, Point Lookout was a favorite place to enjoy the view of the Royal Gorge on the way up the mountain from Old Fort. It provided a respite for cars and weary travelers, as well as a chance to see Sally the bear. (Authors' collection.)

POSTCARD HISTORY SERIES

Swannanoa Valley

Mary McPhail Standaert and Joseph Standaert

Copyright © 2014 by Mary McPhail Standaert and Joseph Standaert
ISBN 978-1-4671-2179-8

Published by Arcadia Publishing
Charleston, South Carolina

Printed in the United States of America

Library of Congress Control Number: 2013952060

For all general information contact Arcadia Publishing at:
Telephone 843-853-2070
Fax 843-853-0044
E-mail sales@arcadiapublishing.com
For customer service and orders:
Toll-Free 1-888-313-2665

Visit us on the Internet at www.arcadiapublishing.com

*This book is dedicated to our daughters,
Diane Standaert and Patricia Standaert Ravenhorst.*

Contents

Acknowledgments		6
Introduction		7
1.	Up from Old Fort	9
	Conquering the Blue Ridge by Stage, Rail, and Automobile	
2.	Ridgecrest	21
	Ridgecrest Conference Center, Mount Mitchell Logging, and Tourism	
3.	Black Mountain: The Key City	35
	Black Mountain, Christmount, and YMCA Blue Ridge Assembly	
4.	Montreat	63
	Montreat Conference Center, Montreat College, and the Town	
5.	The North Fork Valley	81
	North Fork Valley, Black Mountain College, and Mount Mitchell	
6.	Swannanoa Township	101
	Swannanoa, Bee Tree, Warren Wilson, and Riceville	
7.	Beyond Gudger's Bridge	117
	Oteen, Azalea, and Biltmore	
Bibliography		127

Acknowledgments

We would like to acknowledge those individuals who have recorded the past through both the written word and their postcards. Without their texts and images, this book would not have been possible. The more than 1,200 postcards in the authors' collection are the primary source for the images presented here. Unless otherwise noted, images are from the authors' collection. Other cards were generously provided through the courtesy of the Swannanoa Valley Museum (SVM), the Presbyterian Heritage Center at Montreat (PHC), the Black Mountain Center for the Arts (BMCA), and the North Carolina Collection of the Pack Memorial Public Library, Asheville, North Carolina (PACK). Additional cards supplied by others are specifically noted. Finally, we must include thanks to the individuals who have provided research support and graciously reviewed our drafts. We would like to acknowledge: Bill Alexander, Kent A. Barnes, Wendell Begley, John Buckner, Peggy Buckner, Craig Cooley, Vivian Cooley, Roger Hibbard, Robert Goodson, Bob McMurray, Ron Nalley, Stefanie Wilds, Glenda Morrow, Joe Tyson, and Carol Tyson.

Introduction

We invite you to join us on a postcard journey through the Swannanoa Valley, traveling across the Blue Ridge Mountains from Old Fort to the valley's eastern boundary along the continental divide and continuing westward until we reach its westernmost point, at the confluence of the Swannanoa and French Broad Rivers near Biltmore. Geographically some 18 miles long and 6 miles across at its widest, the valley is defined by the drainage of the Swannanoa River, with the waters falling on the valley ultimately flowing into the Gulf of Mexico. We, like the waters of the Swannanoa River, will travel westward from Ridgecrest to Biltmore, with additional stops at Black Mountain, Christmount, the Blue Ridge Assembly, Montreat, the North Fork Valley, Mount Mitchell, Swannanoa Township, Oteen, and Azalea. Home to multiple religious assemblies and the historic Black Mountain College, the valley's name, Swannanoa, is believed by many to be derived from an Indian word meaning "beautiful river" or "beautiful valley."

Historical Events in the Swannanoa Valley

For centuries, the Swannanoa Valley was the land of the Shawano and Cherokee Indians.

1776	Gen. Griffith Rutherford leads a campaign of patriots against the Cherokee.
1784	Pioneer settlement begins.
1815	David Crockett marries Elizabeth Patton of the Swannanoa Settlement.
1857	Dr. Elisha Mitchell falls to his death climbing Mount Mitchell.
1880	The railroad is completed across the Blue Ridge Mountains to Asheville.
1893	The Town of Black Mountain is incorporated.
1894	Warren Wilson College is founded as the Asheville Farm School.
1894	Rafael Guastavino moves to Black Mountain to work on the Biltmore Estate.
1897	Montreat is founded by John C. Collins, a Congregationalist minister.
1903	Asheville begins securing land for its water needs in the North Fork Valley.
1906	The YMCA Blue Ridge Association is founded by Dr. Willis D. Weatherford Sr.
1907	The Ridgecrest Baptist Assembly is founded by Dr. Bernard Spilman.
1916	Montreat College is founded as the Montreat Normal School.
1918	The Veterans Hospital is established in Oteen as an Army hospital.
1924	Grovemont, the first planned housing development in America, is started.
1925	Beacon Manufacturing opens in Swannanoa.
1929	The first 4-H camp in North Carolina is built. It closed in 2013.
1930	The Biltmore Estate is opened to the public.
1933	Black Mountain College is founded by Dr. John Rice. It closed in 1956.
1937	The Western North Carolina Tuberculosis Sanatorium is built.
1942	Moore General Hospital is built to care for 1,500 wounded veterans.
1943	Rev. Billy Graham marries Ruth Bell in Montreat. They make it their family home.
1953	The Burnett dam and reservoir is built.
1967	The Town of Montreat is incorporated.
1975	Railroad passenger service is discontinued.
2002	The Beacon Manufacturing plant closes and burns down in 2003.
2011	The movie *The Hunger Games* is filmed in the North Fork Valley.

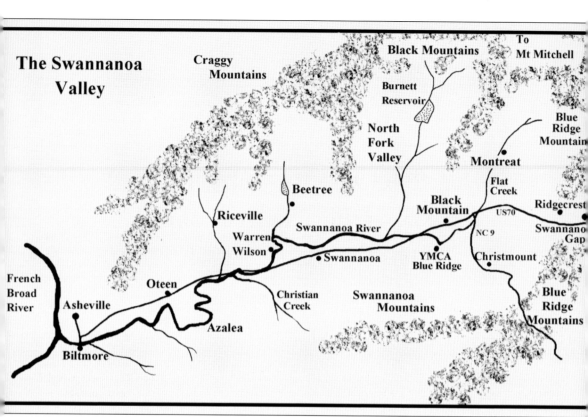

This map sketch shows the towns, boundaries, and geographic features of the Swannanoa Valley, as discussed in this book.

One

Up from Old Fort
Conquering the Blue Ridge by Stage, Rail, and Automobile

The Swannanoa Valley is ringed by the high mountains of Western North Carolina. On the west, it is only open to Asheville and the French Broad River Valley. The northern boundaries are defined by the great Craggy Mountains and the Black Mountains, which boast the highest peaks east of the Mississippi. On the south, the valley is protected by part of the Blue Ridge and the Swannanoa Mountains. The main access from the south is from Bat Cave and the Broad River up through Lakey Gap, the current route of Highway 9. The eastern boundary is guarded by the front line of the famous Blue Ridge Mountains and the eastern continental divide.

The primary route for settlers from the piedmont to Western North Carolina was to climb the Blue Ridge up from the town of Old Fort and enter the valley through the Swannanoa Gap near Ridgecrest. Historically, this was also the dividing line between pre–Revolutionary War settlers and the Indian territories. Over the years, people have used old Indian trails, wagon roads, and stagecoach lines to climb the mountain. Transportation became easier with the completion of the railroad from Old Fort to Asheville in 1880. The construction of this railroad link was an immense undertaking in labor and engineering, and the railroad is still used today.

Later, with the advent of automobile traffic, the Central Highway, or Highway 10, was constructed on the route of an old dirt road up the mountain. This later became the "old" Highway 70, remembered by many for the unique Point Lookout stopping point. Modern traffic from all of Eastern North Carolina to the mountains now uses the route of the "new" Highway 70 (now Interstate 40), which still climbs the front line of the Blue Ridge up from Old Fort to Ridgecrest at the Swannanoa Gap. The town of Old Fort earns its name as "the Gateway to the Blue Ridge."

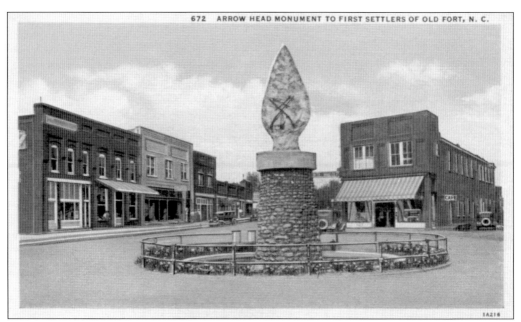

The Old Fort Arrowhead in Old Fort was dedicated on July 27, 1930. It is symbolic of the peace achieved in the previous century between pioneers and Native Americans. It celebrated the Indian pathways and the Davidson Indian Fort, for which the town is named. Until the 1780s, Cherokee lands remained west of the Blue Ridge, and Old Fort was truly the western outpost of North Carolina.

The Proclamation of 1763 by King George III prohibited white settlement in the lands west of the Blue Ridge and defined the Cherokee boundary. After the Revolutionary War, a 1783 treaty temporarily moved the line west to the Pigeon, Holston, and Tennessee Rivers. In 1785, the Hopewell Treaty revoked the 1783 line and established boundaries at Hendersonville, Biltmore, and Marshall, thus opening the Western North Carolina frontier.

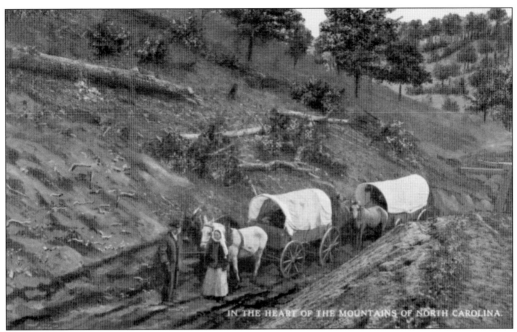

IN THE HEART OF THE MOUNTAINS OF NORTH CAROLINA.

The earliest trail from Old Fort was an Indian trail called the "Suwali," which followed the Catawba River drainage and entered the valley just south of the Swannanoa Gap. This trail terminated at a gap called the "Suwali-Nunnaki." Early settlers using horseback and wagons used this same route. From Old Fort in September 1776, Gen. Griffith Rutherford led a raid on the Cherokee using this early pathway.

UPPER CATAWBA FALLS, BETWEEN RIDGECREST AND OLD FORT, N.C.

Early wagons followed the south fork of the Catawba River, bypassing Catawba Falls, and entered the valley through several gaps, including Old Field Gap and Hungry Gap, both less than a mile south of Swannanoa Gap. It was the early 1800s before the main route changed to Swannanoa Creek, near the Mill Creek drainage. Old road remnants are near the Ridgecrest Camp for Boys, Fortune Fields, and the Black Mountain watershed.

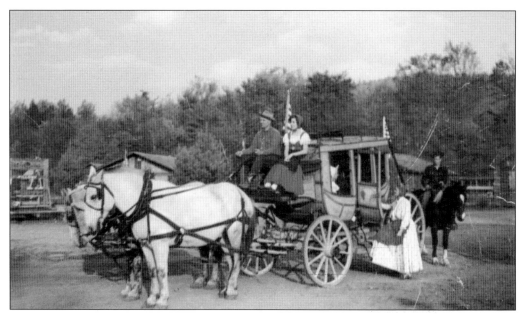

Until the railroad was finally completed to Asheville in 1880, travelers ended their train journey in Morganton, Marion, or Old Fort. Commercial stagecoach lines took them up the mountain to Swannanoa Gap via the Swannanoa Creek route. This route started at Henry's station on Mill Creek, near the present national forest picnic grounds, followed Swannanoa Creek (also called Allison's Creek), and ended at the Swannanoa Gap at Ridgecrest.

Stage stops were the Swannanoa Gap station, Kerlee's (Flat Creek Road), Squire John Stepp's (Blue Ridge Road), and Alexander's (Swannanoa). Around 1816, tolls were levied for using the stage road up from Old Fort. Presumably to avoid charges, Davy Crockett, the son-in-law of Robert Patton of Swannanoa, built a bridle trail from Fairview to Broad River via current Old Fort Road and then to Old Fort.

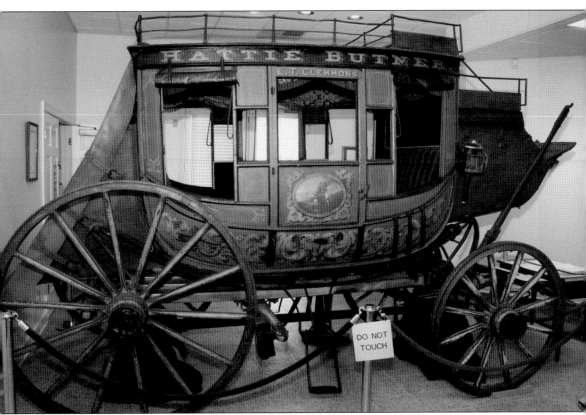

A famous description of a stage ride to the Swannanoa Gap was written in 1876 by Frances Christine Fisher Tiernan in her romance novel *Land of the Sky or Adventures in Mountain By-Ways*, under the pen name Christian Reid. She described a stage driven by John Pence and emerging from dark woods to the gap "on our way to the land of the sky." This has remained a marketing slogan for Western North Carolina ever since. The *Hattie Butner* was the stagecoach driven by John "Jack" Pence for a stage line of Edwin T. Clemmons. It was named for Clemmons's wife. It is now in the Clemmons, North Carolina, Village Hall.

Into the Blue Ridge Mountains, in the Land of the Sky.
Southern Student Conference of Young Men's Christian Associations, Montreat, N.C., June 16-25, 1911

Due to a drought in 1845 and the food shortages endured by the isolated Western North Carolina settlers, the state increased the efforts to complete a railroad connection between the piedmont and the western part of the state. The Western North Carolina Railroad was chartered in February 1855. By the fall of 1858, the railroad was completed from Salisbury to four miles east of Morganton.

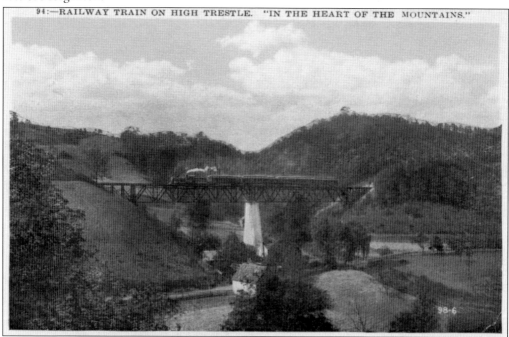

94:—RAILWAY TRAIN ON HIGH TRESTLE. "IN THE HEART OF THE MOUNTAINS."

The construction of the railroad was halted during the Civil War. In 1868, $6.4 million in bonds were sold to complete the Western Division. An embezzlement scandal was perpetrated by George W. Swepson and Gen. Milton S. Littlefield, who successfully fled the state. The scandal led to the impeachment of Gov. William Woods Holden. The railroad reached Marion in 1870 and Old Fort by 1873.

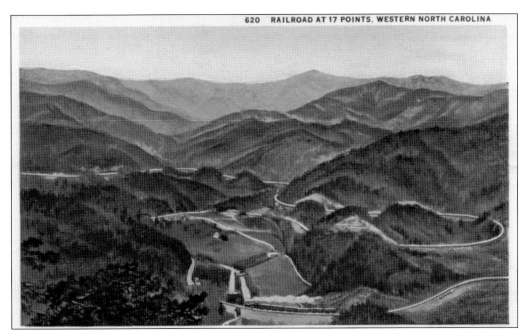

The state bought the Western North Carolina Railroad by the summer of 1875. That same year, James W. Wilson became the chief engineer and superintendent to complete the rail up the mountain. He had originally helped survey the route in the 1860s. His assistant engineer was Thaddeus Charles Coleman, who laid out the final route. Coleman's daughter Sarah married William Sydney Porter of Greensboro, who used the pen name O. Henry.

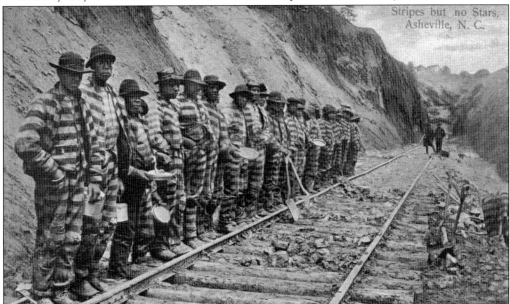

From 1877 to 1879, the railroad was built from Henry's station to Swannanoa Gap. This route required six additional tunnels besides Point Tunnel, including the 1,832-foot Swannanoa Tunnel. The use of convict labor was authorized in 1877. This labor pool ranged from 252 to 766 convicts at various times. The railroad climbed 1,092 feet and required nine miles of rail to complete 3.4 miles of linear distance. (PACK.)

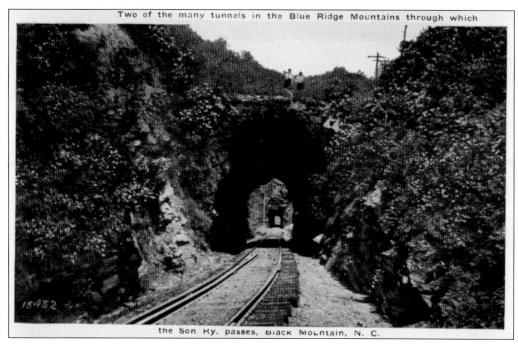
Two of the many tunnels in the Blue Ridge Mountains through which the Sou. Ry. passes, Black Mountain, N. C.

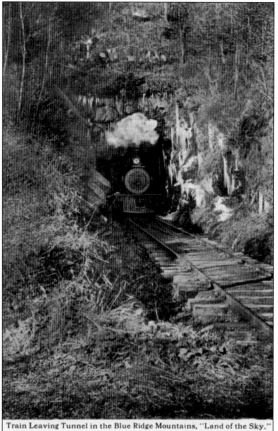
Train Leaving Tunnel in the Blue Ridge Mountains, "Land of the Sky."

In order to speed construction and meet the contract date for completion, Capt. L.S. Aldridge and William Pitt Terrell moved the locomotive *Salisbury* up the old stage road to the Swannanoa Gap by manpower and oxen, and by moving rail sections one at a time. Once at the gap, the engine was used to dig the tunnel concurrently from the western end.

The Swannanoa Tunnel saw one of the first uses of nitroglycerine. The tunnel was dug from both ends. It was completed on March 11, 1879. A telegram was sent from James W. Wilson to Gov. Zebulon B. Vance stating, "Daylight entered Buncombe County this morning through the Swannanoa Tunnel. Grade and centers met exactly." The railroad reached Asheville on October 3, 1880.

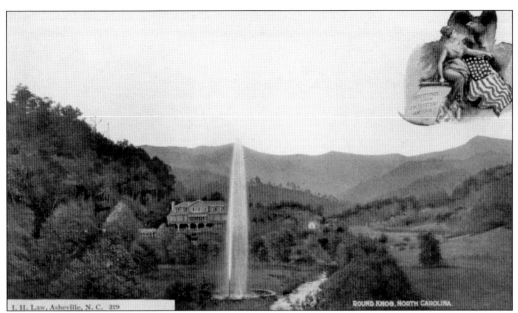

Around 1885, a new five-story tourist hotel called the Round Knob Hotel was built near Mill Creek on the railroad route by James W. Wilson and Alexander Boyd Andrews. This replaced an older structure from the 1870s. A man-made geyser was constructed on the grounds, fed by a stream from up the mountain. After the Round Knob Hotel burned in 1903, the geyser fell into disrepair.

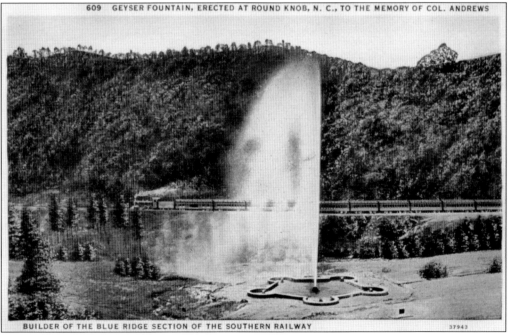

In 1911, George Fisher Baker moved and rebuilt the geyser farther up and across the creek. He then named it for Alexander Boyd Andrews, the vice president of the Southern Railway, and in memory of the men who died building the railroad. The geyser was given to the town of Old Fort in 1975 and restored again.

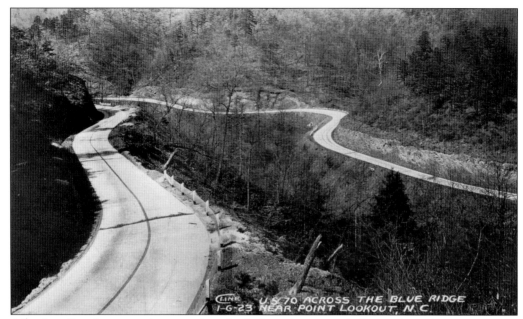

After the railroad was complete, a road was built along the train path that ran from the site of Henry's station, which burned in 1879, to the Swannanoa Gap, above the Swannanoa Tunnel. In 1917, it was still a dirt path. In the 1920s, the mountain-to-sea Central Highway (Route 10) was proposed from Beaufort to Murphy. It was completed up from Old Fort along this route in 1924.

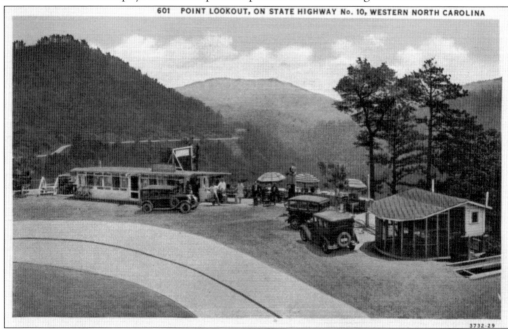

In the 1920s, Route 10 became Highway 70. This highway curved up the mountain and overlooked Royal Gorge and the old Swannanoa Creek drainage of the old stage routes. One of the most memorable places on this route up the mountain was Point Lookout. Presumably, the Point Lookout viewpoint and parking area became the model for overlooks built along the Blue Ridge Parkway. (Chas Fitzgerald.)

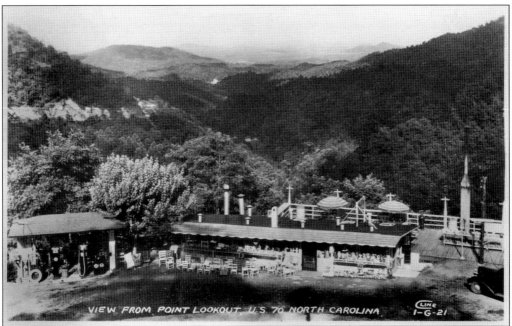

VIEW FROM POINT LOOKOUT U.S. 70 NORTH CAROLINA

Point Lookout boasted a gas station, snack shop, observation platforms, and rooms to rent. It was a welcome stop after the slow and arduous trip up the mountain. The most remembered feature was Sally the bear, who apparently loved to drink out of soda bottles given to her by travelers.

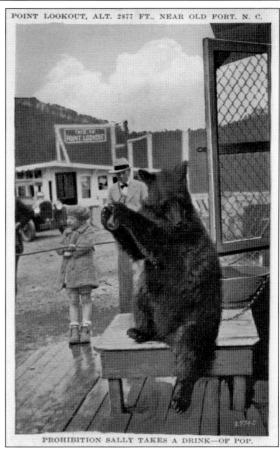

POINT LOOKOUT, ALT. 2877 FT., NEAR OLD FORT, N. C.

PROHIBITION SALLY TAKES A DRINK—OF POP.

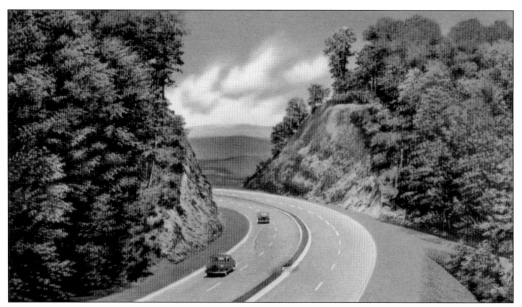

After years of trips up "old" Highway 70, a new four-lane, divided Highway 70 was constructed by July 1954. This highway route moved to the southern face of Young's Ridge and Kitasuma Peak. The "old" Highway 70 route was closed, but it was eventually converted to a paved greenway in October 2008. It is now enjoyed by many walkers, bikers, and hikers, and it includes an enjoyable viewpoint at the old site of Point Lookout.

The last passenger train up the Old Fort rail lines ran on August 8, 1975. In 1974, Highway 70 was upgraded to interstate standards, and Interstate 40 was completed through the Swannanoa Valley by 1979. As noted in the history of Old Fort, current interstate travelers now come through a modern version of the "Sunali-Nunnaki" gap, up from Old Fort, and enter the "Land of the Sky."

Two

Ridgecrest
Ridgecrest Conference Center, Mount Mitchell Logging, and Tourism

After climbing the face of the Blue Ridge from Old Fort, we begin our journey into the eastern part of the Swannanoa Valley. The first community in the "Land of the Sky" is Ridgecrest. It is best known today as the home of the Lifeway Ridgecrest Conference Center, with its signature white cross visible from the Swannanoa Gap. This location was selected by Dr. Bernard Washington Spilman in 1906 as the site for the Southern Baptist Assembly. His vision was a place for Baptists "to meet and to learn how to teach the Bible to the multitudes." For over 100 years, the Ridgecrest Conference Center has grown and spiritually nourished generations of Baptists. The conference center has been aptly called a "Mountain of Faith."

Prior to Dr. Spilman, the top of the gap was the site of the Swannanoa Gap station for collecting tolls on the stage road. After the railroad arrived in 1880, there was a small telegraph office and a post office, both named Terrell. Around 1907, the area was renamed Blue Mont for the Blue Ridge Mountains. In 1912, after the name Skymont was considered, the final name, Ridgecrest, was picked, in reference to the "Crest of the Blue Ridge." Just west of Ridgecrest was the site of a logging company sawmill, as well as the start of the Mount Mitchell narrow gauge railroad, heading for the slopes of Mount Mitchell and the Black Mountains, 18 miles away. Started in 1912 as a logging operation, it included passenger rail excursions until 1919, allowing tourist access to Mount Mitchell.

In 1922, after logging ceased, the Mount Mitchell Development Corporation constructed an automobile toll road that mostly followed the old rail bed. The Mount Mitchell Scenic Auto Road operated until 1939, when it became obsolete with the creation of the Blue Ridge Parkway. Col. Sandford Cohen was the marketing genius behind the railroad and toll road. Known for his alliteration, he referred to the route as "Making the Apex of America Accessible," and also called it a "Trip of Perfect Peerless Panorama of Unsurpassed Magnificence."

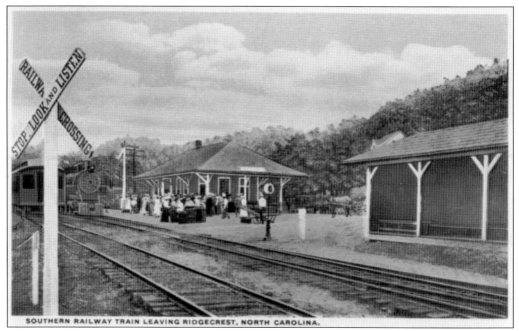

SOUTHERN RAILWAY TRAIN LEAVING RIDGECREST, NORTH CAROLINA.

The top of the Swannanoa Gap was where people entered the "Land of the Sky." The first stagecoach stops were the Swannanoa station at the gap and Grey Eagle, at Kerlee's near Flat Creek Road. After the railroad arrived, a telegraph office called Terrell was located near the Swannanoa Gap, named for William Pitt Terrell, an early engineer on the railroad. (PHC.)

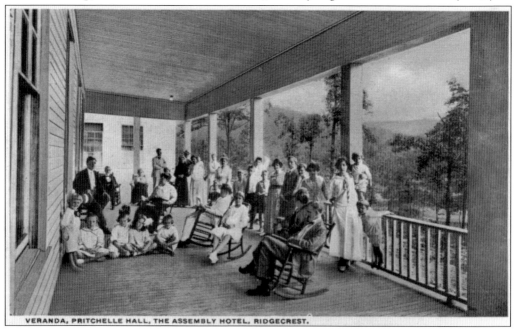

VERANDA, PRITCHELLE HALL, THE ASSEMBLY HOTEL, RIDGECREST.

In 1901, Dr. Bernard Washington Spilman was appointed field secretary for the Sunday School Board of the North Carolina Baptist Convention. In the summer of 1902, he attended a Sunday School Training Conference at the Mountain Retreat Association and remarked that the "Baptists ought to have something like this." He began a five-year search for a suitable site.

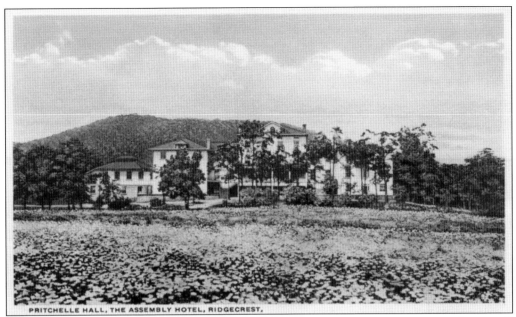

PRITCHELLE HALL, THE ASSEMBLY HOTEL, RIDGECREST.

On August 4, 1906, Dr. Spilman met James A. Tucker, an Asheville attorney, at the Terrell station. Tucker was active at Montreat and had completed the Montreat charter. They inspected 940 acres above Swannanoa Gap, and Dr. Spilman recommended the purchase to the Baptist Assembly in December 1906. His vision was a place for Baptists "to meet and to learn how to teach the Bible to the multitudes."

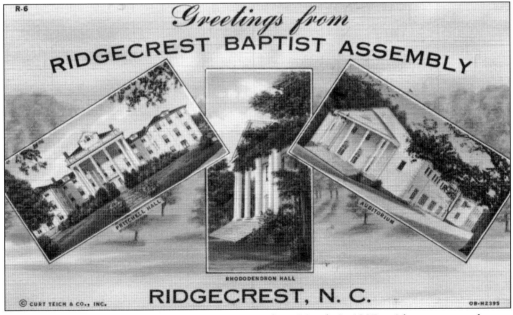

The Southern Baptist Assembly was incorporated on March 8, 1907, with a mayor and a tax collector. It was located in Blue Mont (later Ridgecrest). The assembly stayed a municipality for 27 years. It was surveyed and platted in the fall of 1907 by Chauncey Delos Beadle, who laid out the Biltmore Estate. Lots were sold for $100 each, and they included one share of stock. Only Baptists could get shares. Of the 500 lots available, 140 were sold, raising $14,000.

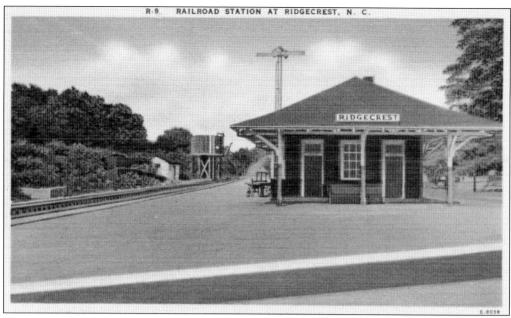

The name Blue Mont was changed to Ridgecrest in 1912, either because a railroad station with the same name existed in Robeson County or because the telegraph designation would be the same as Black Mountain (BL MT). Skymont was also suggested, but Ridgecrest was finally selected, in reference to the "Crest of the Blue Ridge." It took Dr. Spilman's effort to get the Terrell post office and telegraph office names changed.

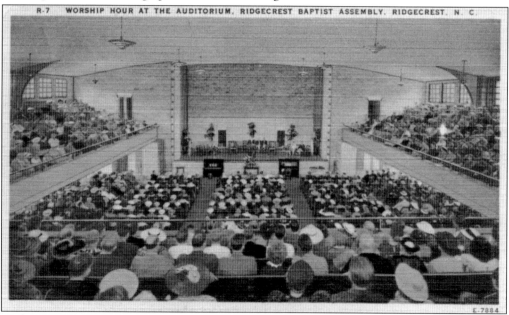

The first sermon on the grounds occurred in 1909. Admission to the grounds was free, but an admission fee was charged for programs. The original auditorium was at the current location of Camp Ridgecrest for Boys. It was destroyed by a windstorm in 1914. In early years, windstorms and debt and loan problems occurred. Later, Dr. Spilman said, "The world, the flesh and the devil set in to destroy the Assembly."

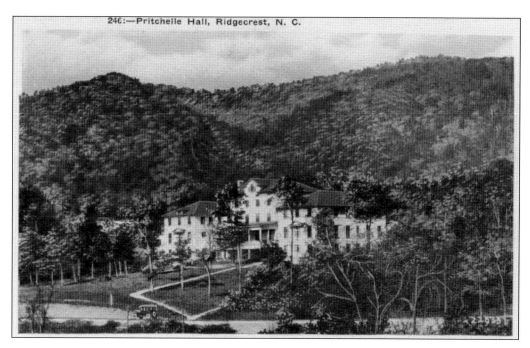

On August 21, 1911, construction started on the Pritchelle Inn (later named Pritchell Hall). Judge Jeter C. Pritchard was the chairman of the board, and the construction was done by Joseph Duckworth "J.D." Elliott, later the mayor of Hickory. The name was a combination of Pritchard and Elliott. The family of J.D. Elliott still lives in Black Mountain and Montreat. It was completed by August 1914 and remodeled in 1925, when the white columns replaced the original porches. Pritchell Hall was torn down in 1962 and replaced in 1964.

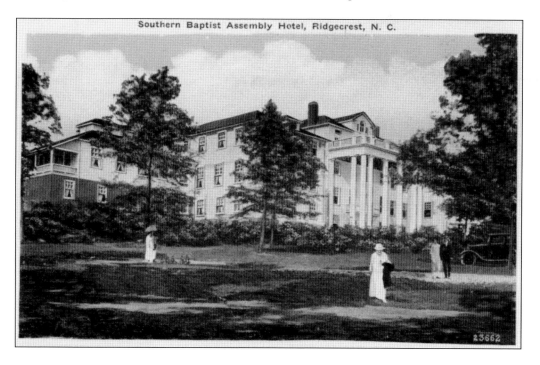

This is a view of Camp Ridgecrest for Boys. In 1924, the 15-acre Lake Ridgecrest was proposed. In 1926–1927, Mrs. Willie Turner Dawson ran a girls' camp called Camp Star Note. The cabins and two-story home were purchased from Dr. Spilman. His house was originally named White Oak Lodge and was the first home built in Ridgecrest. The girls' camp was discontinued by 1928 and became the boys' camp by the summer of 1929.

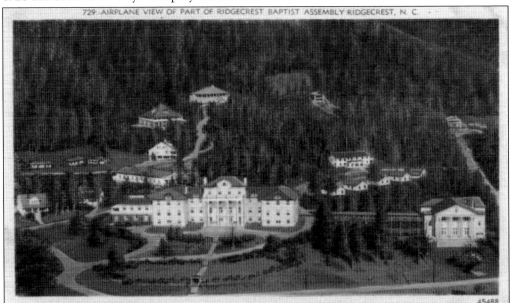

In January 1925, Rev. Raymond Fowler Staples began a 10-year career as the business manager during which he completed major expansions. In 1926, Rhododendron Hall was completed for dining, with a wooden bridge connecting it to Pritchell Hall. In 1925–1926, the Springdale cottages and annex were built, as were the "bird huts," as well as the water reservoir, chlorinator, and sewer system.

In 1919–1920, the Baptist Education Board controlled Ridgecrest. The Baptist Executive Committee and the Sunday School Board ran the center from 1929 to 1944. In 1934–1935, the original Southern Baptist Assembly was dissolved, and the charter was changed to Ridgecrest Baptist Assembly. By 1944, title passed exclusively to the Sunday School Board. In 1972, the named was changed to Ridgecrest Baptist Conference Center. Finally, in 1999, it became the Lifeway Ridgecrest Conference Center.

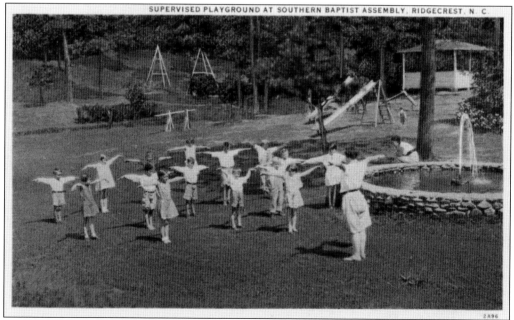

In 1935, Dr. Thomas Luther Holcomb became the director of the Sunday School Board. The next dozen years saw more major expansions of the facilities. In 1938, Spilman Auditorium was built. From 1942 to 1947, the Crestridge Hotel, a new dining hall, and classrooms were built. The Hemphill property and 63 acres south of the future interstate were also acquired during that period.

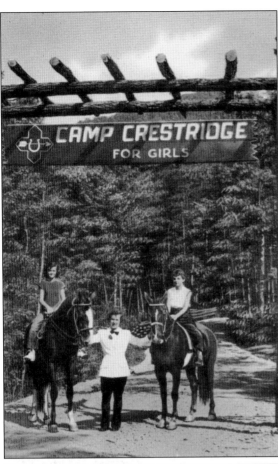

Dr. Spilman died in March 1950. He was succeeded by Dr. Willard K. Weeks, who acquired the William H. Belk property for the expansion of the water system and for recreation. In 1953, Camp Crestridge for Girls opened. In the 1950s, the Florida Cove and Royal Gorge Apartments were completed, as well as the new reservoir and the Children's Building.

In 2002, the 228-room Mountain Laurel Inn was completed, as well as the Rutland Chapel. After more than 100 years, Dr. Spilman's dream for the conference center was very evident: it was a vibrant "Mountain of Faith."

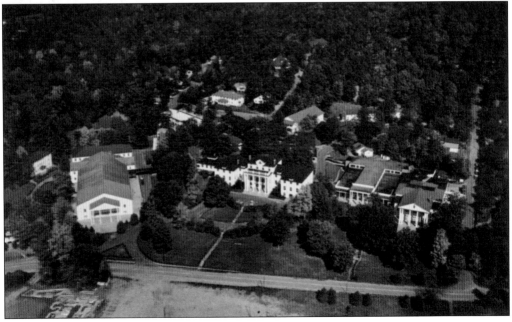

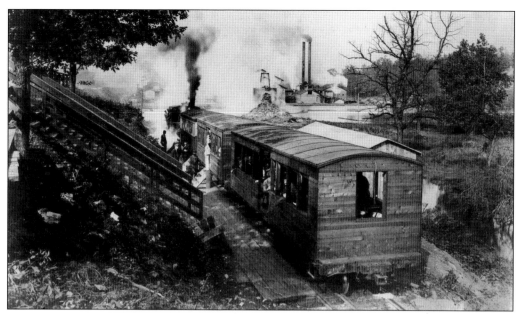

In 1911, the Dickey & Campbell Company of Marion, Virginia, acquired timber rights to 9,000 acres of spruce and fir on the southern and eastern flanks of the Black Mountains. Clarence A. Dickey and Joseph C. Campbell built a narrow gauge rail line from Black Mountain to the slopes of Mount Mitchell. The double-cut band sawmill was located between Ridgecrest and Black Mountain, where Interstate 40 is today. (PHC.)

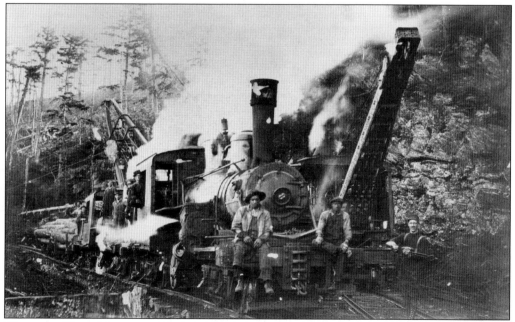

The sawmill could process 110,000 board feet of lumber per day. In order to transport the potentially 200 million board feet of red spruce and Fraser fir down to the mill, a narrow gauge railroad was built using donkeys, dynamite, and manual labor. This railroad was completed in one year and consisted of three trestles, nine switchbacks, and 18 miles of track. It gained 3,500 feet in altitude. (PHC.)

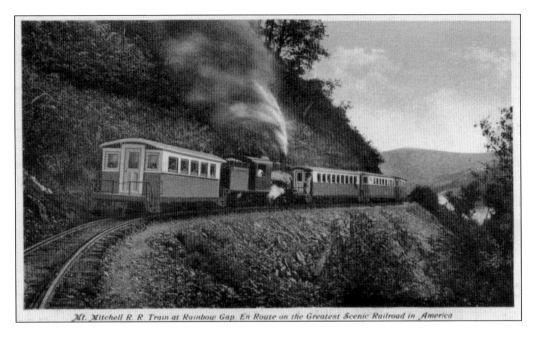
Mt. Mitchell R. R. Train at Rainbow Gap. En Route on the Greatest Scenic Railroad in America

The right-of-way for the Dickey & Campbell rail line was acquired from private individuals such as William H. Belk and others. In addition, six miles of access was granted through Montreat for $500 per mile and 15¢ per cross tie cut. Judge James D. Murphy, the Montreat president, negotiated the original contract, but it was not signed until Dr. Robert C. Anderson became president in 1911. Dr. Anderson added a clause to rescind the access after logging was complete. These images show the passenger rail in Montreat at Rainbow Gap (above) and on the Big Slaty switchbacks (below), which is now the Greybeard hiking trail. (Above, PHC.)

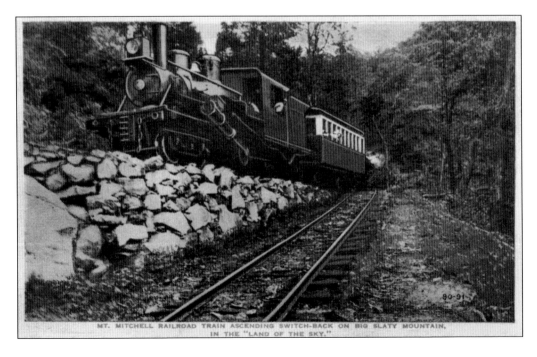
MT. MITCHELL RAILROAD TRAIN ASCENDING SWITCH-BACK ON BIG SLATY MOUNTAIN, IN THE "LAND OF THE SKY."

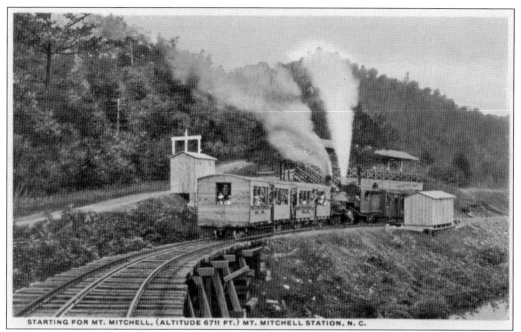

STARTING FOR MT. MITCHELL, (ALTITUDE 6711 FT.) MT. MITCHELL STATION, N. C.

In 1913, Frederick A. Perley and William H. "Bert" Crockett bought the logging operation from the Dickey & Campbell Company. From 1913 until 1919, the Perley & Crockett Lumber Company added passenger cars on the logging railroad for tourist access to Mount Mitchell. In 1915, the Mount Mitchell station was dedicated, allowing tourists on the standard gauge trains from Asheville to transfer to the narrow gauge train for the rest of the trip to Mount Mitchell.

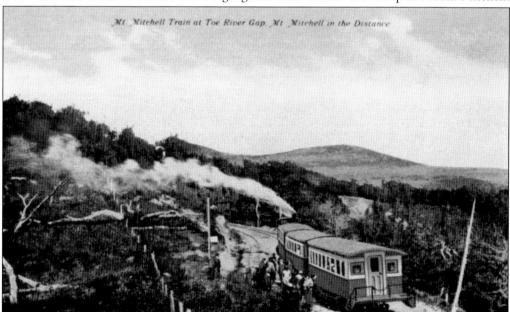

In August 1915, the round-trip fare from Asheville, including changing to the Mount Mitchell Scenic Railroad, was $2.50. The fare included a hot meal on the mountain and included four hours at the summit. The trip was 21 miles long and took over three hours. At the railroad's peak, it carried as many as seven cars and 250 people per trip.

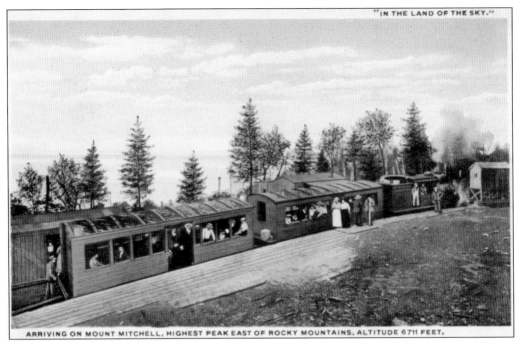

The tourist destination at the end of the railroad was Camp Alice, below the summit of Mount Mitchell. It had a dining room and overnight accommodations. A scenic, but steep, one-mile trail exists from Camp Alice up to the summit of Mount Mitchell and the observation tower. In 1916, there were 10,000 visitors to Camp Alice.

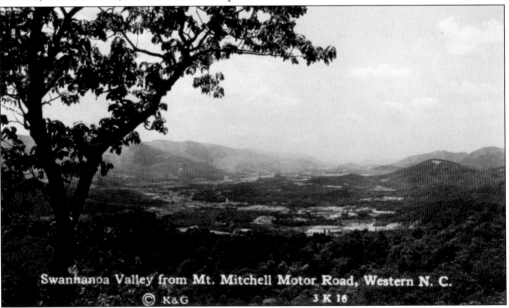

The tourist railroad ended in 1919, as the railroad was needed to complete logging operations. When logging ceased on August 15, 1921, the Mount Mitchell Development Corporation was formed to again provide tourist access to Mount Mitchell. Fred Perley and Clarence A. Dickey proposed an auto road over the old rail bed. In September 1921, a condemnation suit was filed against Montreat to allow the auto road on Montreat property.

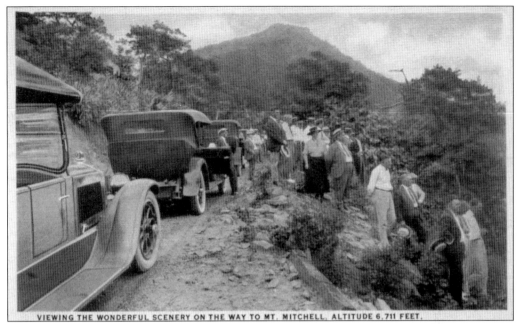

VIEWING THE WONDERFUL SCENERY ON THE WAY TO MT. MITCHELL, ALTITUDE 6,711 FEET.

A court ruling upheld Dr. Robert Anderson's right-of-way contract clause requiring that the land revert to Montreat after the logging was complete. The Development Corporation was thus forced to reroute the auto road, bypassing the six miles of rail bed within Montreat. In arguing against the road, Dr. Anderson said it would pollute the water supply and "expose the institution to the irresponsible public."

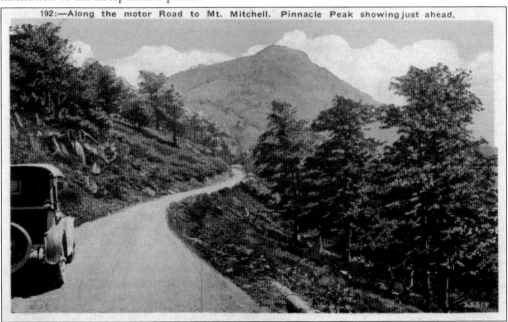

192:—Along the motor Road to Mt. Mitchell. Pinnacle Peak showing just ahead.

The Mount Mitchell Motor Road was completed within one year after logging ceased, officially opening on June 26, 1922. Promotions by Col. Sandford H. Cohen touted the road as "Making the Apex of Appalachia Accessible." In 1923, a total of 13,000 people drove the 19 miles to Camp Alice.

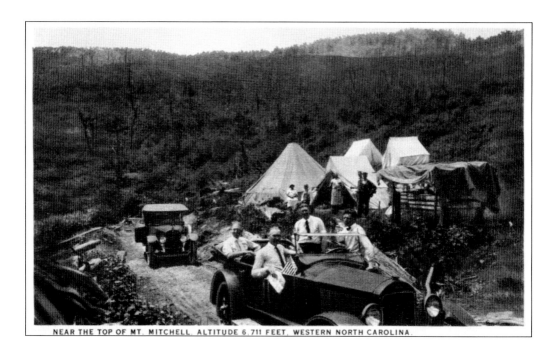
NEAR THE TOP OF MT. MITCHELL, ALTITUDE 6,711 FEET, WESTERN NORTH CAROLINA.

The Mount Mitchell Motor Road was one-way up the mountain from 8:00 a.m. until 1:00 p.m. Traffic then reversed, and cars were only allowed to go down from 3:30 p.m. until 5:30 p.m. Overnight stays were possible at Camp Alice. The fare was $1 per adult and $3 minimum per car. The motor road was used until 1939 or 1940, when the (free) Blue Ridge Parkway was completed to the Mount Mitchell Park entrance.

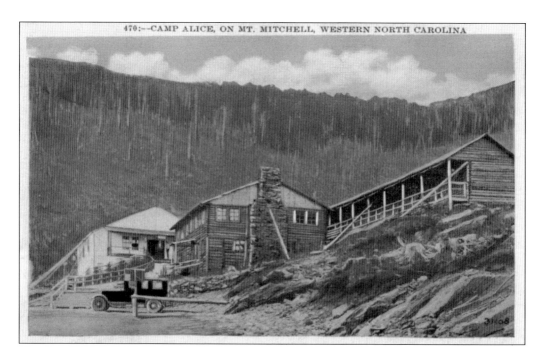
470:—CAMP ALICE, ON MT. MITCHELL, WESTERN NORTH CAROLINA

Three

Black Mountain
The Key City
Black Mountain, Christmount, and YMCA Blue Ridge Assembly

Until the arrival of the railroad in 1880, Black Mountain was a sparsely settled farming community known as Grey Eagle. Incorporated in 1893, the town chose the name of Black Mountain, to match the name of the railroad station, and set its limits with the station as the town center. Black Mountain was a major train stop for tourists traveling through the North Fork Valley to the Craggy and Black Mountains, "summer people" escaping from the heat, those hoping to recover from tuberculosis in the healthy mountain air, and conferees attending religious assemblies.

In 1915, the Charlotte-Salisbury-Asheville Division of the Southern Railway Company advertised that Black Mountain was the "greatest religious center in the world," containing "communities in which more than ten million Christians of various denominations are directly or indirectly interested." Black Mountain still serves the needs of nearby religious assembly grounds, with the large tracts of land purchased by these groups protecting much of the mountain's beauty. Ridgecrest, at 1,300 acres, lies to the east, and the 4,500-acre Montreat lies to the north. In the 1890s, noted Spanish master builder Rafael Guastavino moved to Black Mountain to work on the Biltmore Estate. He purchased over 1,000 acres, which are now home to Christmount. In the early 1900s, the YMCA Blue Ridge Association, under the leadership of Dr. Willis D. Weatherford Sr., purchased over 1,500 acres just to the south of town, flanked by High Top and Jesse's High Top Mountains.

With a population of some 250 in 1893, the town is home to 7,500 people today. It is called "The Little Town That Rocks" and has a rocking chair as its logo. Black Mountain is the major commercial center of the eastern Swannanoa Valley.

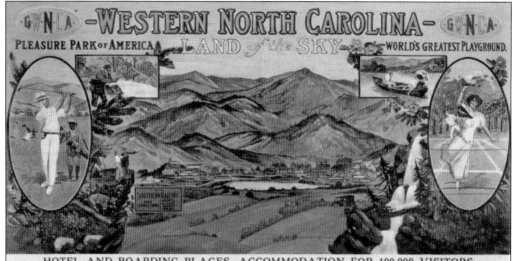

The train brought tuberculosis patients seeking a cure, tourists seeking relief from the heat of the low country and the scenic vistas of the mountains, and tradespeople seeking their fortune. At the beginning of the 20th century, the Southern Railway promoted the "Land of the Sky" as the "Pleasure Park of America" and the "World's Greatest Playground," with accommodations for 100,000 visitors.

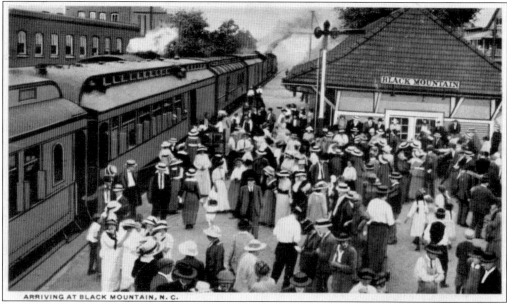

Passenger service reached Black Mountain in 1880, and as many as 10 trains per day once stopped at the Black Mountain station. A sign at the station read "Black Mountain – Salisbury 123.1 miles – Washington 461.5 miles." In 1915, tickets cost 3¢ per mile for those attending religious conferences. Hotels and boardinghouses were built, and taxis met the train to take arrivals to their final destinations. Passenger service ended on August 8, 1975.

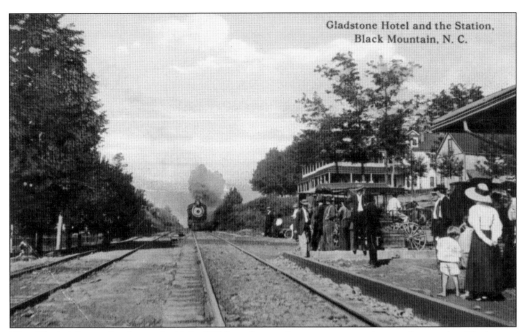

The Black Mountain depot, built in 1909, welcomed passengers staying at the nearby Gladstone Hotel and was the primary stop for those attending conferences at Blue Ridge and Montreat, as well as tourists making their way to the Craggy and Black Mountains and Mount Mitchell through the trails of the North Fork Valley and Montreat.

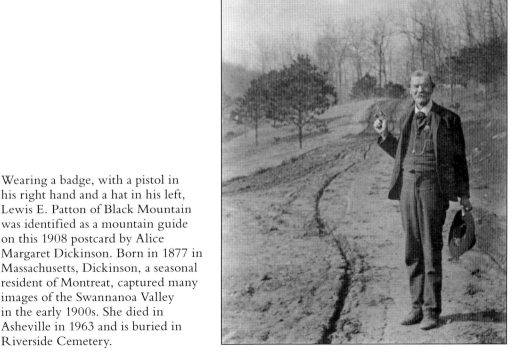

Wearing a badge, with a pistol in his right hand and a hat in his left, Lewis E. Patton of Black Mountain was identified as a mountain guide on this 1908 postcard by Alice Margaret Dickinson. Born in 1877 in Massachusetts, Dickinson, a seasonal resident of Montreat, captured many images of the Swannanoa Valley in the early 1900s. She died in Asheville in 1963 and is buried in Riverside Cemetery.

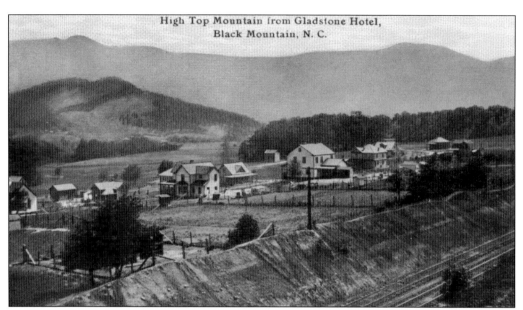

Guests at the Gladstone Hotel had clear views of High Top Mountain and the Blue Ridge Assembly. Across the tracks, large homes lined Vance Street, named for Zebulon Baird Vance, a North Carolina Civil War officer, governor, US senator, and North Fork resident. Shortly after the Civil War, Vance, an attorney, unsuccessfully defended Tom Dula, who was convicted of murder, hung, and immortalized in the folksong "Tom Dooley."

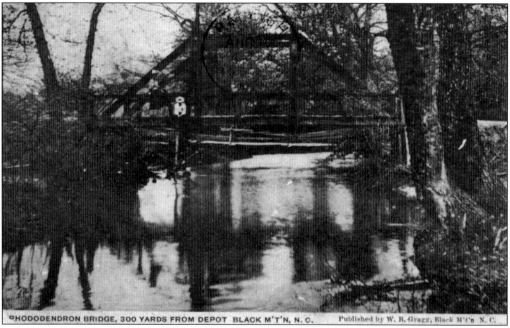

Rhododendron Bridge spanned the south fork of the Swannanoa River (Flat Creek) some 300 yards southeast of the "Black M'T'N" depot. W. Bingham Gragg, who captured this early-1900s fishing scene, published one of Black Mountain's first postcard images. In 1929, Gragg built a photography studio of river rock at 221 West State Street. He later moved to 100 Church Street, into a house built by businessman R. Harley Reed.

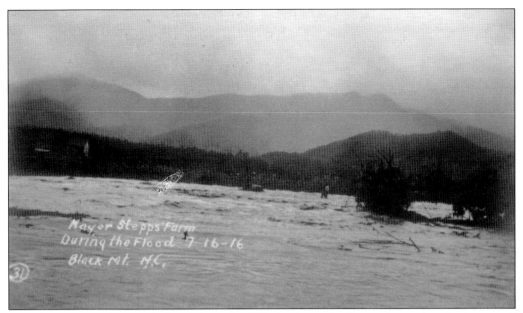

On July 16, 1916, Flat Creek flooded much of Black Mountain. It was already swollen by runoff from clear-cut mountain slopes, and then more than 22 inches of rain fell in 24 hours. Mayor George Washington Stepp's 25-acre farm, between Vance Street and Flat Creek, was inundated, as seen here. Fortunately, his two-story Queen Anne–style home, built in 1907, escaped destruction. Today, the house is located at 115 Black Mountain Avenue.

The small community of Grey Eagle grew around the railroad station on Sutton Avenue. On March 4, 1893, the town was incorporated and the name was changed to Black Mountain. Paradoxically, although the town was named for the railroad station, which served as the portal to the Black Mountain Range, it is difficult to see the Black Mountains from the town. The town limits were drawn with the railroad station as the town center.

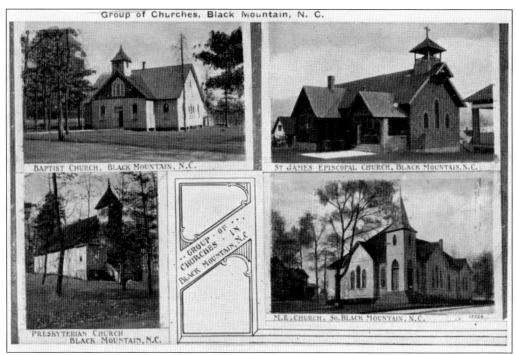

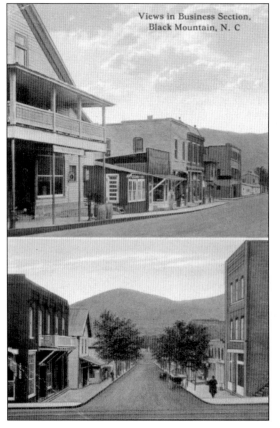

Residents and visitors could worship with many denominations, including Black Mountain Baptist Church, established in 1905; Black Mountain Presbyterian Church, established in 1908 on Montreat Road; St. James Episcopal Church, established in 1907 on Vance Street; and the Methodist Episcopal Church, established in 1890 on Church Street. The town's first library was established in 1922 in Black Mountain Presbyterian Church, with 50 books for children. The original St. James sanctuary still stands today. (SVM.)

Retail stores and a funeral home operated along Depot Street (now Sutton Avenue, top) and South Main Street (bottom, now Black Mountain Avenue). Many are now gone, but the Pappas Building, on Sutton Avenue, bears the inscription, "Sam Pappas, 1914." The McKoy Building, with its balcony available for second-floor "roomers," remains on Black Mountain Avenue. Built with a street-level grocery, it also housed the town hall until 1905 and was used as an infirmary during the 1918 flu epidemic.

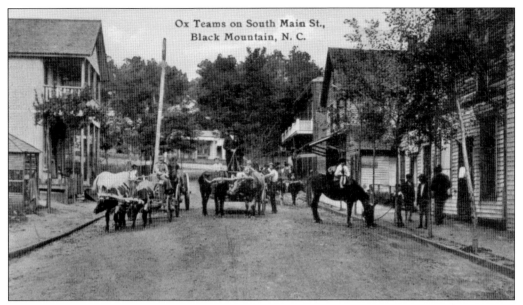

Black Mountain's first mayor, Thomas K. Brown, resigned on August 11, 1893. He was replaced that same night by Silas F. Dougherty, who then immediately resigned and was replaced by Columbus P. Kerlee. The town meeting was deemed "extraordinary." The first automobile arrived in 1909, spurring town commissioners to issue the first road bonds in Buncombe County to macadamize Highway 10. By 1915, Cherry Street, Sutton Avenue, and South Main Street were paved.

In 1912, a fire started near the corner of Cherry Street and Sutton Avenue and destroyed much of the commercial center. A fire department was then organized, and it purchased a used REO fire truck from Asheville. The fire department moved to its new home, designed by Richard Sharp Smith at 223 West State Street, in 1922. The building now houses the Swannanoa Valley Museum, which was organized in 1989.

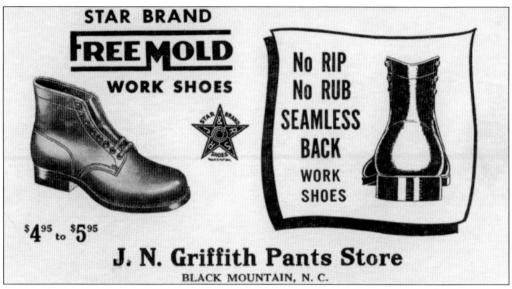

The 1910s and 1920s were boom years for the area. The Griffith family moved from Florida and opened the J.N. Griffith Pants Store, which also sold FreeMold shoes, as seen here. In 1915, William H. McMurray Sr. and Frank L. Jackson owned another notable business, the Carolina Feed & Furniture Store, at 119 Cherry Street. McMurray moved to Black Mountain seeking a cure from tuberculosis. He opened the Chevrolet dealership on July 4, 1935. Jackson was the treasurer of Davidson College from 1913 to 1952 and the mayor of Davidson from 1951 to 1967.

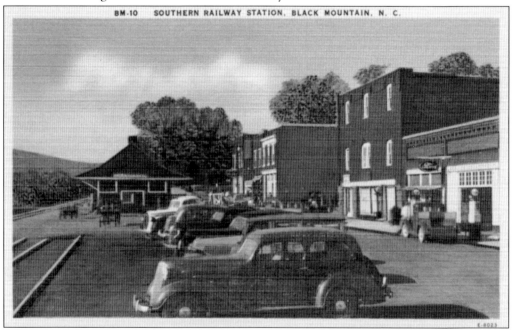

Located at the corner of Sutton Avenue and Cherry Street, the Brown Brothers Livery offered arrivals at the depot in 1911 "Careful Baggage Handling and Comfortable Turnouts." With the arrival of automobiles and motorized taxi service, Clarence and Bert Brown opened a Ford agency, the town's first car dealership. Their half-brother Lawrence Brown was the sheriff of Buncombe County for 34 years, from 1926 to 1928 and then from 1930 to 1962.

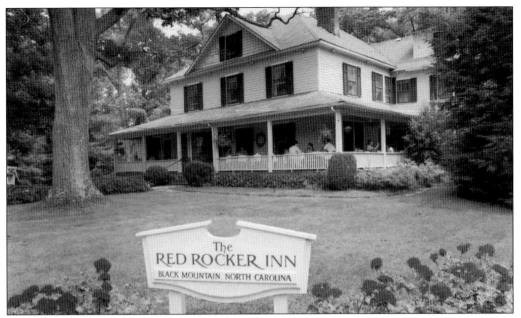

Hotels and boardinghouses were built for tourists. Arch Tyson operated Tyson's Inn in the upper North Fork from 1893 until the property was acquired for the Asheville watershed in 1903. His son Alfred Forbes Tyson Sr. married Sadie Dougherty of Black Mountain around 1910. The couple operated the Dougherty Heights Inn at 136 North Dougherty Street for decades. The inn continues its long tradition of hospitality as the Red Rocker Inn.

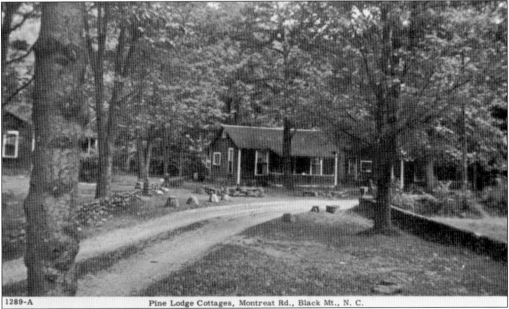

Pine Lodge (now Cabin Creek Lodge) was built around 1926 as a hunting camp on nine acres bordering Flat Creek alongside Montreat Road. Many of the original structures remain today. The rhododendron railings and furniture were handcrafted by German immigrant John Hentschel (1866–1940), who opened a rustic furniture shop in Ridgecrest around 1920. Hentschel's work has been featured at the Asheville Museum of Art.

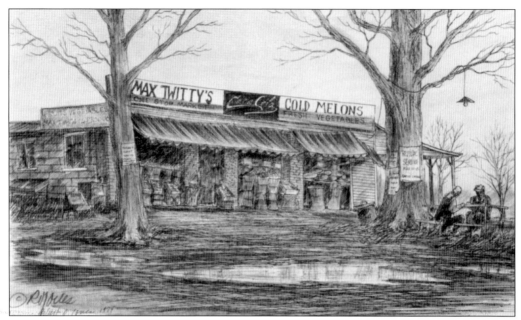

Guests at Pine Lodge and travelers along Montreat Road in the 1960s often stopped at Max Twitty's stand on East Street to buy fresh produce and enjoy Coca-Cola and cold watermelon. (Robert Jones.)

By 1929, Black Mountain was known as "the Key City," with Montreat, Blue Ridge, and Ridgecrest Assemblies within a three-mile radius. The State Sanatorium for Tuberculosis was built in 1937, and the Blue Ridge Parkway was largely completed in 1939. Many came to Black Mountain seeking work, including George and Elizabeth Whittaker, who moved from Madison County to Montreat Road in the 1910s. Their granddaughter Catherine Marshall wrote the novel *Christy*.

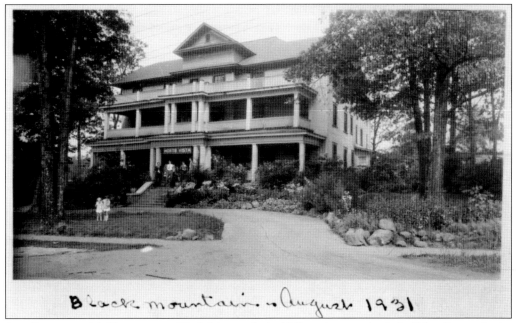

Rosalie Jumper Phillips came to Black Mountain in 1919 to manage the Lake Eden Resort in the North Fork Valley. Instead, she purchased Black Mountain's wooden three-story school building from the board of education for $3,350. She then remodeled it, adding porches, and opened the Monte Vista Hotel with 26 rooms and 16 baths (above). In 1937, the remodeled school was replaced by the brick building below, which had 51 guest rooms. Materials from the old wooden structure were used to build the Black Mountain Airport buildings in the 1930s, just west of town. In 1992, the former airport became the Billy Graham broadcasting station, and it has since been replaced by an Ingles warehouse. Managed by the Phillips family for eight decades before changing ownership, the Monte Vista is the only remaining hotel in Black Mountain. A long list of hotels have been lost to time, progress, or fire, including the Black Mountain Hotel, the Gladstone, the Washington, and the Peabody, on Sunset Mountain (Miami Mountain).

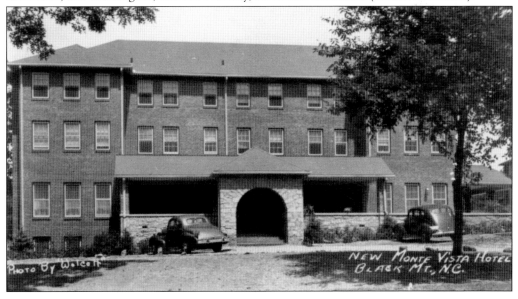

John Gary and Claudia Crawford McGraw operated a coffeehouse in the 1920s, adjacent to their home at 203 East State Street. An accomplished cook and seamstress, Mrs. McGraw was featured in *Southern Living* and gained national acclaim as "the Apron Lady," selling her aprons from her home and in New York boutiques. Highly collectable, her aprons were owned by Gloria Vanderbilt, as well as missionaries and her many friends. (BMCA.)

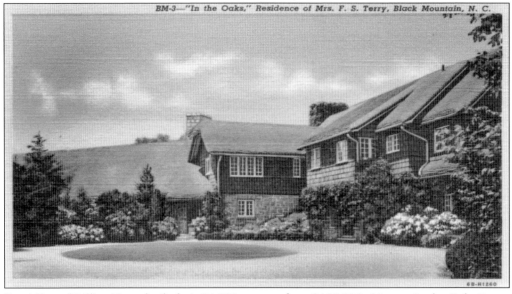

Franklin and Lillian Terry built their 24,000-square-foot, $600,000, 80-acre In the Oaks Estate in 1921, adding a wing designed by Richard Sharp Smith in 1923. Terry's company, Ansonia Electric, developed a "long-lasting" lightbulb. Terry died in 1926 at only 64 years of age. The first woman to drive the Mount Mitchell Toll Road, Mrs. Terry died in a car accident in Florida on April 21, 1954. The estate was bequeathed to the Episcopal Church, and Montreat College purchased it in 2001.

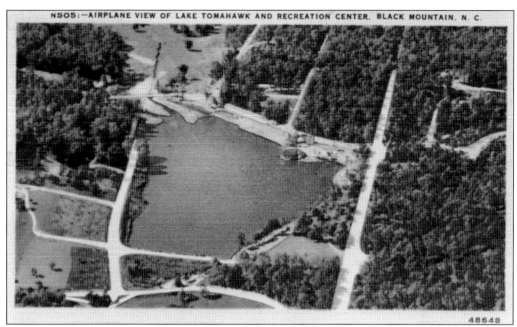

In 1916, the Methodist Colony Company offered 1,200 lots for sale within a quarter mile of the Black Mountain depot, calling the town "The Greatest Religious Center in the Southern States." The Methodists, however, established their conference center at Lake Junaluska, and the town of Black Mountain then bought the 1,200 lots on December 4, 1933. The Civil Works Administration built Lake Tomahawk and the clubhouse there during the Great Depression.

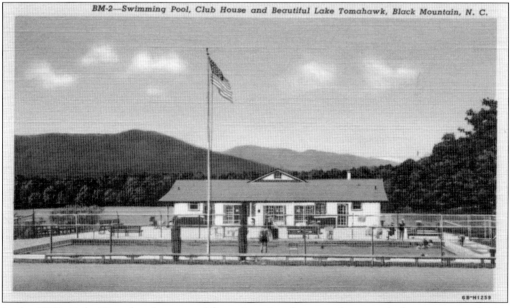

In the 1930s, Lake Tomahawk was used for swimming, but a pool was ready for summer activities by 1941. The first nine holes of the Black Mountain Golf Course, designed by Donald Ross, were opened in 1929, and the back nine were completed in 1962. The 17th hole, measuring 747 yards, was certified as a par-six regulation hole and was once touted as "the longest golf hole in the world."

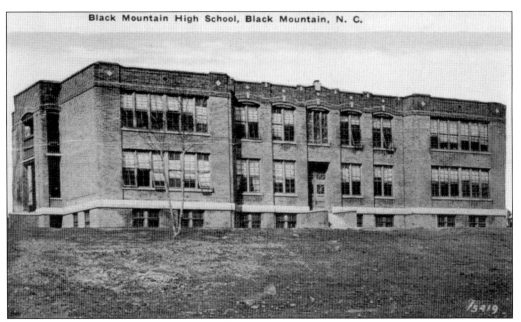

The 1933 History Club at Black Mountain High School compiled the earliest history of the community, relying, in their own words, "on folk-lore and legend as documented facts were few." Built on Flat Creek Road in 1927, the high school graduated its last class in 1954, as Swannanoa and Black Mountain High Schools merged on January 25, 1955. The Swannanoa Warriors and the Black Mountain Darkhorses became the Owen High School Warhorses.

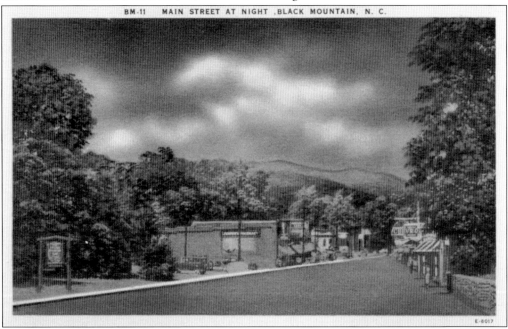

The business center shifted north to State Street as automobile travel increased. Looking east, businesses in the 1930s and 1940s included the Village Workshop, Jumper's Pharmacy, the A&P Grocery, McMurray Chevrolet, Lance's Esso station, and the New Theatre, built by Lee A. Hiltz, who originally came to Black Mountain in the 1920s as an employee of Franklin Terry.

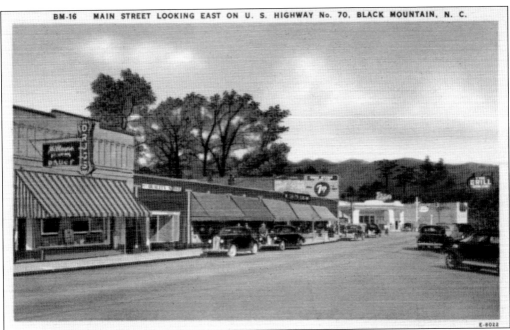

In 1927, the gas station at the corner of Montreat Road and State Street, the site of Black Mountain's town square, pumped more gasoline than any other station in North Carolina. The New Theatre, just to the east on State Street, was renamed the Pix and was managed by Lee Hiltz's stepson Laddie Terrell. It closed in the 1960s.

```
    FREE              YOUR              FREE     F
            PIX THEATRE, BLACK MOUNTAIN N.C.     R
    is sponsoring a contest to find the "CHILD OF   E
    THE YEAR". Here is a chance to see your child   E
    on the THEATRE SCREEN and perhaps win ONE of the
    LOCAL PRIZES.
    Contest open to all children up to 12 yrs.
    To enter bring your children to the
                    PIX THEATRE
    anytime between 11am and 5 pm. on WED. MAY 7.
    A series of NATURAL COLOR poses will be taken.
    You persolally will select the pose to enter the
    contest.
         NO ENTRY FEE, NO CHARGE, NO OBLIGATION
    SEE ALL THE LOCAL CHILDREN ON THE THEATRE
    SCREEN IN GLORIOUS NATURAL COLOR.
    YOUR PIX THEATRE. WED. MAY 7 11am to 5 pm
```

In 1952, the Pix sponsored the Child of the Year contest, open to all children up to 12 years old. With no entry fee and no obligation, parents could have their child's picture taken and shown on the Pix Theatre's screen. Always accommodating, the Pix opened for Montreat College girls on Mondays, since their weekends were "Sunday-Monday," to ensure students would only worship and rest on Sundays before studying on Mondays.

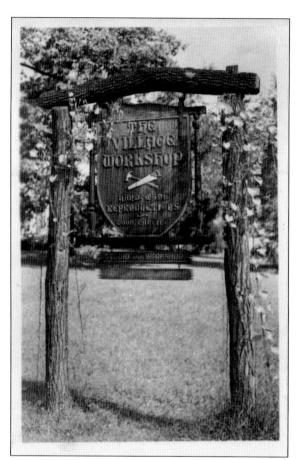

Edward DuPuy opened the Village Workshop near the corner of Church and State Streets in the 1930s, handcrafting fine furniture. A renaissance man, DuPuy built a wooden pipe organ, taught woodworking at Black Mountain College, and was a cofounder of Highland Farms. He later turned his interest to photography, and his pictures and postcards record much of the mid-20th-century history of the Swannanoa Valley.

The intersection of Broadway (Highway 9) and State Street was the heart of the business section in the 1940s and 1950s. Uzell's Drugstore, Black Mountain Hardware, Firestone, and an auction house (on the former site of the bowling alley) anchored the corner. Broadway was the new home of the expanded A&P supermarket, and, in 1946, the Tyson Furniture Store opened on Broadway next to the post office.

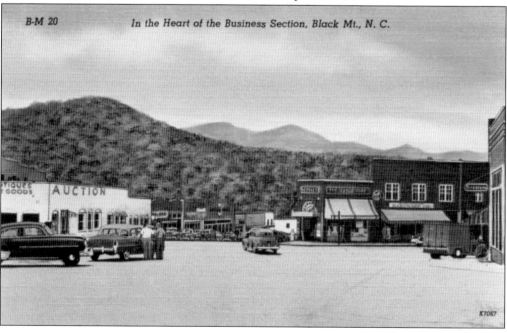

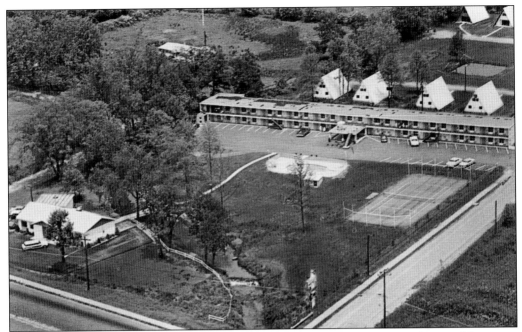

With the rerouting of Highway 70 up from Old Fort in 1954 and the completion of Interstate 40, motels replaced older hotels and boardinghouses. In her novel *Body Farm*, Patricia Daniels Cornwell, a former Montreat resident and an Owen High School graduate, featured many locations in Black Mountain, including the Travel-Eze Motel and Lake Tomahawk.

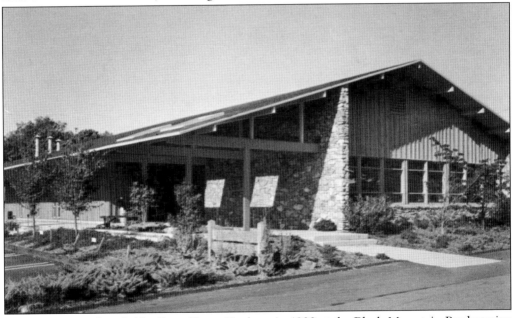

The library was founded by Rev. Harry Boehme in 1922 at the Black Mountain Presbyterian Church, with 50 children's books. After being funded by the town in 1927, it was long housed at the town hall (now the Black Mountain Center for the Arts). In 1965, the library joined the Buncombe County system, and it moved in 1968 to a new facility financed and built by the community at 105 North Dougherty Street.

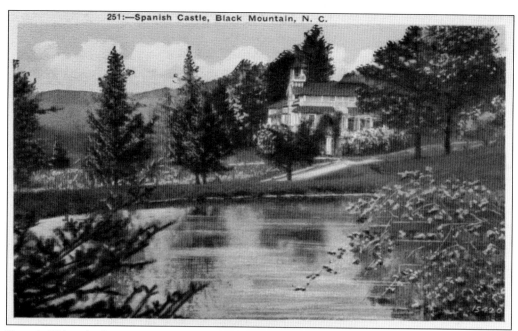

Born in Valencia, Spain, in 1842, Rafael Guastavino Sr. and his son immigrated to New York in 1881. Guastavino then came to Black Mountain in 1894 with his second wife, Francesca, to work at the Biltmore Estate. Guastavino assembled a 1,000-acre working estate named Rhododendron and built a three-story wooden home known as the Spanish Castle. The house was partially destroyed by fire in 1940, but the wine cellar and foundations and a kiln remain.

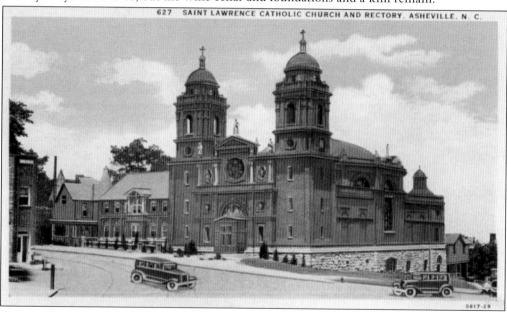

Guastavino patented the "Tile Arch System" to build expansive vaulted ceilings using thin tiles and quick-setting cement. Designs from the Guastavino Company can still be found in over 600 buildings, including the Biltmore Estate and Carnegie Hall. The vaulted ceiling in Asheville's St. Lawrence Catholic Church (seen here) in 1905 was his last project. He died in 1908 and is interred in the St. Lawrence Church. Francesca died in 1946 and is buried at Riverside Cemetery.

Christmount, located two miles south of Black Mountain on Highway 9, is the 620-acre year-round assembly grounds of the Christian Church, Disciples of Christ. Following an actual dream of founder Frank Dixon in 1947, it was established in 1948 as the Southern Christian Assembly, with the property purchased from the Guastavino estate for $15,000. It was renamed Christmount Christian Assembly in 1954, following a "$1,000 Lot for New Name" contest.

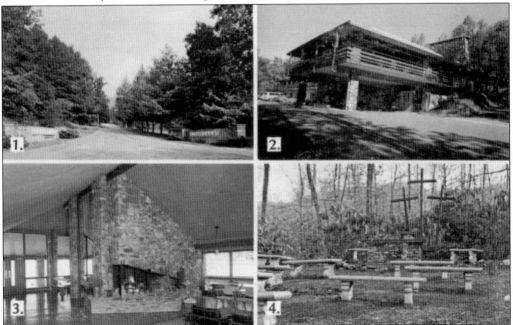

The first conference in 1949 was held in the Guastavino stable. Roads and buildings were constructed, including the entrance (1), the guesthouse (2), the lounge and fireplace (3), and the outdoor worship area (4), as well as the Dixon Park residential community. The current Settings housing development in Black Mountain was once part of the Guastavino estate.

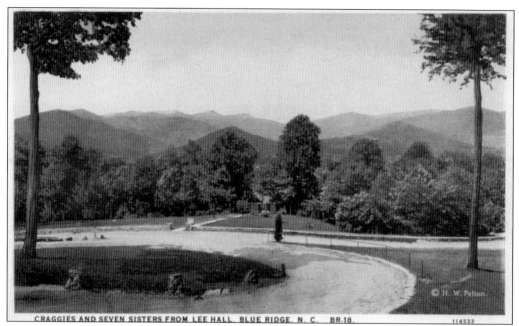

On October 6, 1906, Willis Duke Weatherford Sr. climbed a tree on the slopes of the Swannanoa Mountains, looked north, and exclaimed to Dr. Alexander Phillips, superintendent of Sabbath Schools for the Southern Presbyterian Church: "Eureka, we have found it!" This ended Weatherford's search for training grounds for the Young Men's Christian Association (YMCA). In 1904, Weatherford declined an offer to purchase Montreat, declaring that, with 33 homes, Montreat would be too distracting.

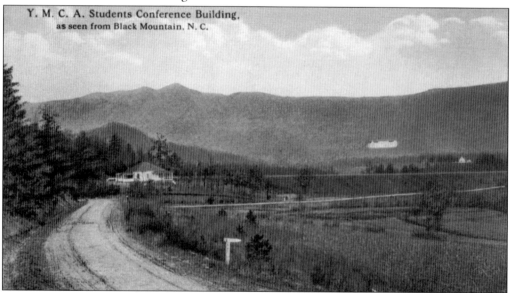

Located two miles southwest from Black Mountain, the site, now home to the YMCA Blue Ridge Assembly, provided an expansive view of the Craggy and Black Mountains. Earning his PhD in 1907 from Vanderbilt University, Weatherford served as president of Blue Ridge from 1906 to 1944 and was a leading advocate for improved race relations. He and his wife, Julia, are buried on the grounds.

Dr. Weatherford arranged financing on his own initiative to purchase 942 acres of heavily timbered forest abounding with game and rushing streams for $11,500, and he soon acquired an additional 622 acres. A 1925 brochure of the picturesque Blue Ridge Association proclaimed, "Come to the mountains, drink of their crystal waters and gain health and vigor from their bracing atmosphere."

The virgin forests of Blue Ridge were logged, raising money to cover 50 percent of the land cost. Herbert W. Pelton, an Asheville photographer and postcard publisher, captured the logging operation. The large diameter of this downed tree was emphasized by Pelton's selection of one of the crew's shortest members, Edward Sneed, the father of Monie A. Sneed, to pose by the tree. (SVM.)

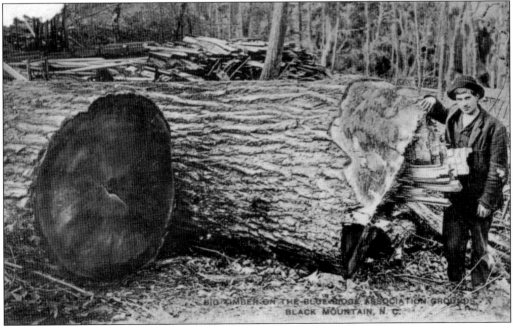

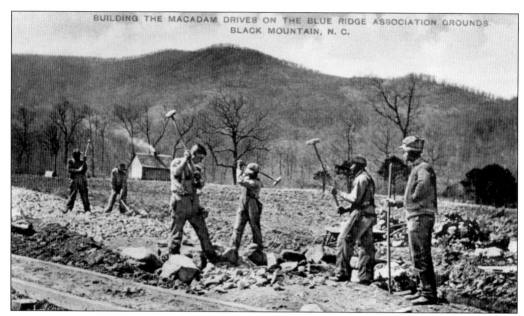

Crews built macadam roads three miles up the mountain slope using pickaxes and hammers to reach the site selected for the erection of Robert E. Lee Hall, the signature building of the assembly grounds and the location of the "Eureka" tree climbed by Weatherford. From 1906 until 1912, conferences were held in other locations, including Montreat and the Asheville Farm School (now Warren Wilson College).

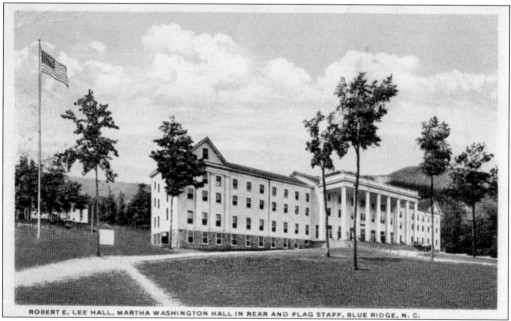

Designed by New York's Louis Jallade in a neoclassical style with meeting rooms, a dining hall, and a capacity of 400, Lee Hall was built in 1911–1912. The Young Women's Christian Associations (YWCA) held the first conference on the grounds in June 1912, with over 1,000 delegates in attendance. Martha Washington Hall was completed in 1914 to house the female college staff, known as PWGs, or "Poor Working Girls."

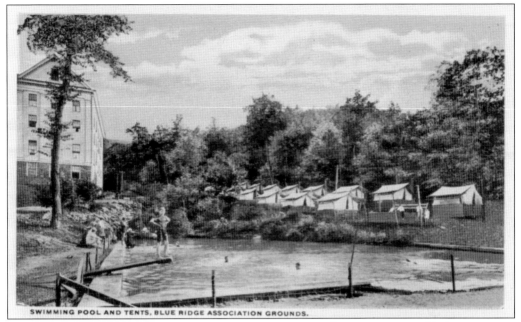

SWIMMING POOL AND TENTS, BLUE RIDGE ASSOCIATION GROUNDS.

A large tent colony provided needed overflow housing in the 1910s. Two gabled wings were soon added to Lee Hall. A gymnasium, an auditorium, a library, tennis courts, athletic fields, a swimming pool, and cottages were built in the following decades. By the 1930s, the campus boasted more than 50 structures.

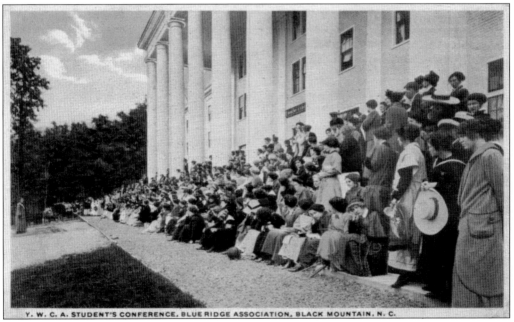

Y. W. C. A. STUDENT'S CONFERENCE. BLUE RIDGE ASSOCIATION, BLACK MOUNTAIN, N. C.

In 1912, two young sisters from China, Soong Ching-ling and Soong Mei-ling, attended a conference at Blue Ridge Assembly. In 1915, Ching-ling married Sun Yat-Sen, the first president of the Republic of China. She later served as vice-chairperson of the People's Republic of China from 1959 to 1975. In 1927, Mei-ling married Gen. Chiang Kai-shek, the president of mainland China and Taiwan from 1928 to 1975.

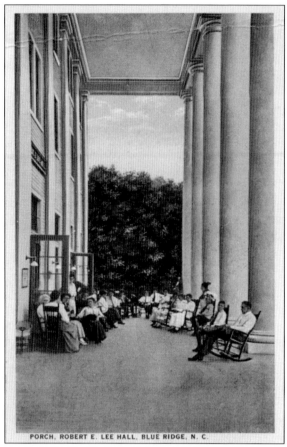

PORCH, ROBERT E. LEE HALL, BLUE RIDGE, N. C.

With the exception of the three-story Doric columns supporting the front porch, Lee Hall was built with timber harvested from the grounds. The wooden columns were manufactured in the Midwest and shipped east by rail. While sitting in the green rocking chairs lining the porch, generations have enjoyed the view of the Swannanoa Valley seen by Drs. Weatherford and Phillips in 1906. The "Eureka Tree" stands at the southeast corner of Lee Hall.

Dr. Weatherford met Julia McCory, a Winthrop College YWCA delegate to Blue Ridge, in 1912. Two years later, they married in the home of Winthrop college president David Bancroft Johnson. Blue Ridge had its own post office until the 1970s. On the back of this postcard, postmarked 1914, a woman named Mary wrote her sister: "Dear Annie, Your sad letter came. My girl, we all weep together and would sit down and write you a long letter but would be with you real soon."

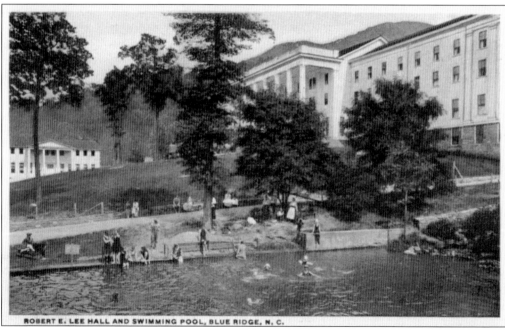

ROBERT E. LEE HALL AND SWIMMING POOL, BLUE RIDGE, N. C.

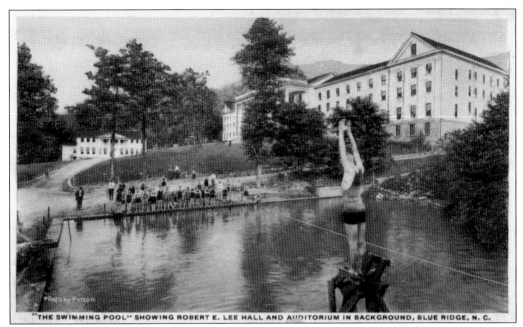
"THE SWIMMING POOL" SHOWING ROBERT E. LEE HALL AND AUDITORIUM IN BACKGROUND, BLUE RIDGE, N. C.

Daniel Carter Beard received the only Gold Eagle Scout badge ever awarded by the Boy Scouts at Blue Ridge in 1922. One of the founders of the Boy Scouts of America in 1910, he received his Eagle Scout Award in 1915 at the age of 64. Beard was the editor of *Boys' Life* magazine. The Lee High School for Boys operated in the winters from 1926 to 1932, teaching "Health, Education, Character and Religion."

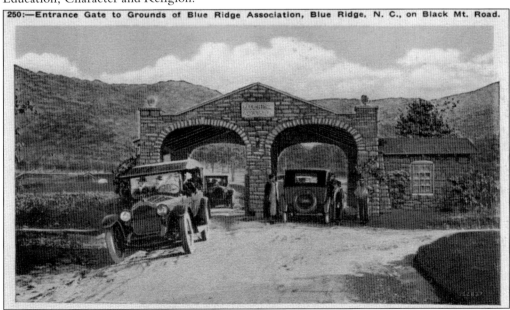
250:—Entrance Gate to Grounds of Blue Ridge Association, Blue Ridge, N. C., on Black Mt. Road.

The 1925 season extended from June 5 to September 21. In 1924, a total of 4,368 conferees came through the Blue Ridge Assembly gate. Each guest was greeted with a "hearty welcome! Extending hospitality, but not exclusiveness, yet at the same time ensuring privacy and protecting against undesirable persons." The gate was locked from midnight to 6:00 a.m. A 1927 brochure requested that guests "Be courteous to the gateman."

ROADWAY APPROACHING ROBERT E. LEE HALL, BLUE RIDGE ASSOCIATION, BLUE RIDGE, N. C.

Dr. John Andrew Rice, a professor of classics at Rollins College, was fired for his radical views on higher education. He then went on to found Black Mountain College. On August 23, 1933, a lease was signed with Blue Ridge for the winter use of its facilities, with funds provided by the Forbes family of New England. Black Mountain College began its 23-year experiment in education with 10 faculty members and 22 students. Black Mountain resident Gary McGraw, the son of Claudia Crawford and John Gary McGraw, was a day student. In 1937, Dorothy Elizabeth "Dottie," the adopted daughter of educational reformer Dr. Harold Rugg, joined the student body, and met and married Gary McGraw. She went on to serve as Black Mountain's librarian from 1961 to 1983. Black Mountain College moved to its Lake Eden location, in the North Fork Valley, in 1941. It purchased the Lake Eden property in 1937 because of concerns that Blue Ridge would not renew their lease.

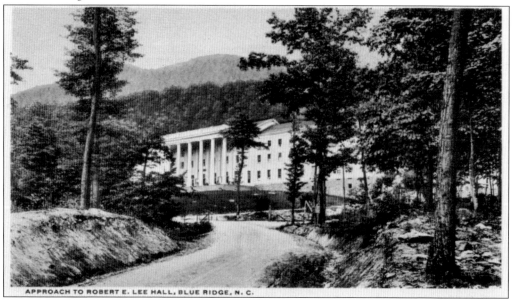

APPROACH TO ROBERT E. LEE HALL, BLUE RIDGE, N. C.

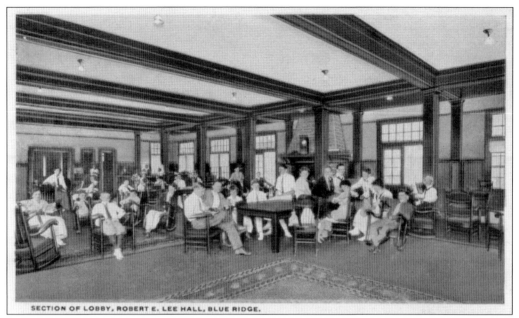

In the summers, the immense lobby of Lee Hall hosted gatherings of men and women in Christian fellowship under the leadership of Dr. Weatherford. In the winters from 1933 to 1941, the lobby was populated by the college as well as well-known visitors, including playwright Thorton Wilder; educational reformer John Dewey; sociologist Herbert Miller; Aldous Huxley, the author of *Brave New World*; and poet Charles Olson, who permanently joined the faculty at Lake Eden in 1947.

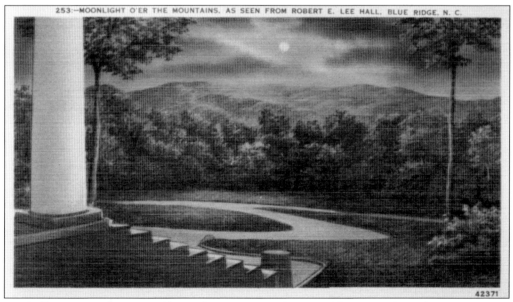

Josef Albers, a visual artist, and his wife, Anni, a textile artist, of Germany's Bauhaus movement, joined the Black Mountain College faculty in 1933, fleeing the rise of Nazism. Speaking little English and unfamiliar with the ways of North Carolina, they were surprised to learn that notes could be posted on the massive columns of Lee Hall, not realizing the columns were of wood, not marble. The Albers left for Yale University in 1949.

In 1943, the Blue Ridge Association was purchased by the Southern Associations of the YMCA and became formally known as Blue Ridge Assembly. In the 1960s, the campus provided a peaceful lunch stop for busloads of Freedom Riders as they traveled southward. In 1966, the Atlanta Falcons football team held their summer training camp at Blue Ridge. The Blue Ridge Conference on Leadership has held conferences there since 1919, and the Fellowship of Christian Athletes has held conferences there since 1964. In 1970, year-round programming began, with more than 35,000 guests per year enjoying the beautiful grounds. They find "rest, recreation, and inspiration," a fitting tribute to the vision of Dr. Willis D. Weatherford Sr. more than a century ago, when he exclaimed, "Eureka, we have found it!"

Four

Montreat
Montreat Conference Center, Montreat College, and the Town

Montreat is nestled in a cove of 4,500 acres on the eastern edge of the Blue Ridge Mountains, 18 miles from Asheville and 2 miles from downtown Black Mountain. Established in 1897 by an interdemoninational group largely from the North, it was the first religious assembly founded in the Swannanoa Valley. Today, it is the second-oldest in the country, predated only by Ocean Grove, in New Jersey. In 1906, Montreat was purchased by individual Presbyterians, largely from the South, beginning its long association with the Presbyterian Church.

Today, Montreat consists of three entities: the town of Montreat, incorporated in 1967; Montreat College, founded in 1916; and the Mountain Retreat Association, founded in 1897, which serves, but is not owned by, the Presbyterian Church (USA). It is also home to the Presbyterian Heritage Center and the Chapel of the Prodigal. Founded on the site of a former sheep ranch that was begun in 1888, Montreat is bounded by the Blue Ridge Mountains to the east and the slopes of the Seven Sisters (Walkertown Ridge) to the west and north. All traffic must enter and exit through its southern boundary, where Highway 9 ends or begins, depending upon whether one is entering or leaving the cove. The headwaters of the south fork of the Swannanoa River are high on the slopes of Greybeard Mountain. In 2004, the Mountain Retreat Association placed 2,450 acres in a permanent conservation easement with the State of North Carolina, protecting these headwaters and the beauty of the cove forever.

In the winter months, Montreat is a small town, with 700 residents consisting of equal numbers of year-round residents and Montreat College students. In the summer, the population swells with part-time residents and conferees. For many, Montreat is considered a "mecca of Presbyterians," "a place set apart," and even the "narthex of heaven."

Montreat was chartered by the State of North Carolina as the Mountain Retreat Association (MRA) on March 2, 1897. In 1898, a contest was held for a simpler name. The winner was Montreat, a portmanteau of "Mountain" and "Retreat" submitted by Jeannie Palmer of Valdese, North Carolina. This 1923 pennant card expresses the wishes of many who come to Montreat: "We're having lots of fun . . . But wish you were here too!"

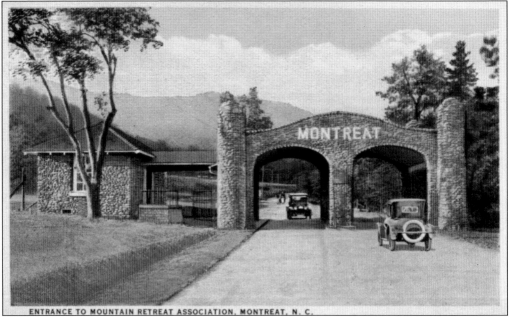

In a long-standing Montreat tradition, generations continue to sing the following song as they pass through the Montreat gate: "Montreat, how I love you, how I love you, my dear old Montreat/I'd give the world to be, among the folks in M-O-N-T-R-E-A-T . . . Waiting for me, praying for me, down by Lake Susan/The folks back home will just have to wait 'til I get through that Montreat gate."

The first meeting of the Woman's Auxiliary of the Presbyterian Church (US), or PCUS, was held in Montreat in 1912. In 1922, to celebrate its 10th anniversary, the auxiliary held its first Birthday Offering Gift, designating $2,500 to build the stone Montreat gate. Hallie Paxson Winsborough (left) was the first superintendent of the auxiliary and was the first woman to ever speak before the PCUS General Assembly, at Montreat in 1923. Note that "Winnsborough" is spelled incorrectly on this postcard.

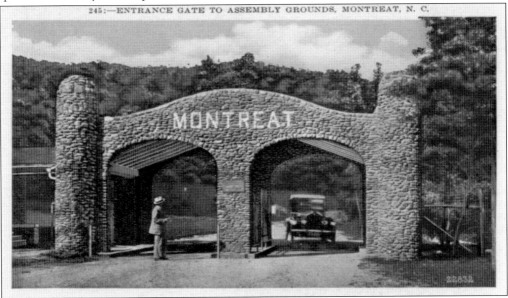

Members of the Melton family, stonemasons from Black Mountain, helped build the Montreat gate in 1923. The small stone building housed college men during the two months of the summer conference season. Called "gateboys," their duty was to man the metal gates blocking the archways, collecting entrance fees from residents and conferees alike. Not all were happy with this fee. The gates were open during the remainder of the year.

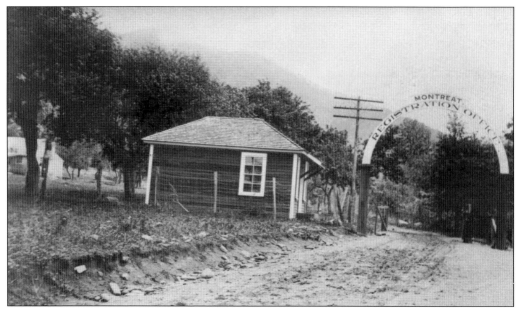

The arched wooden gate at the cove's entrance was present by 1909. Kenneth Foreman Sr. was the first gateboy in 1913. His son Kenneth Foreman Jr., was a gateboy in 1942. His grandson Samuel Foreman was among the last gateboys in 1969. Graduates of Davidson, Haverford, and King College, respectively, all three became Presbyterian ministers. The gate fee was abolished soon after the Town of Montreat was incorporated in 1967.

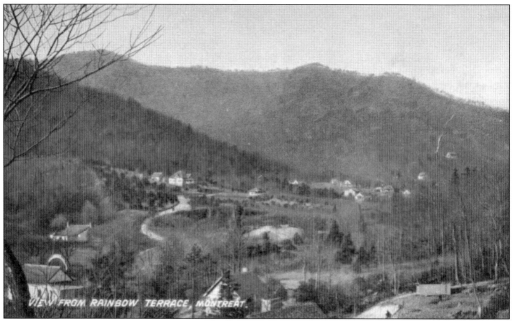

In 1888, sheep ranchers, including Pell Sutton and James Maney of Black Mountain, purchased the valley from Anderson Kelly for $1 per acre. The venture failed. In 1897, a group led by John Chamberlin Collins of New Haven, Connecticut, purchased the property for $8 per acre to establish a "health resort for rescue mission and church workers broken in health and spirit." The Kelly farmhouse is just above the arch in the bottom left of this 1909 postcard.

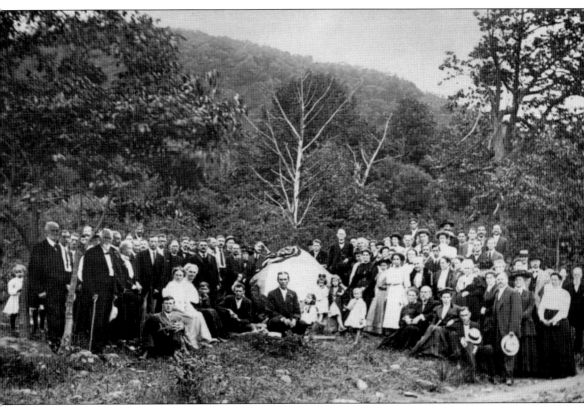

In 1909, the community gathered to dedicate the Montreat Rock with the inscription, "Montreat Founded by John C. Collins 1897." John Huyler, Montreat's second president, from 1900 to 1905, funded the dedication but was unable to attend. John Collins (the second man standing to the left of the rock) was a Congregationalist minister from New Haven, Connecticut, a leader of the Boys Club of America, the father of 10, and the first president of Montreat, from 1897 to 1899. Rev. James Howerton, the third president of Montreat, from 1906 to 1908, stands to the immediate left of Collins (white shirt and tie). Elisabeth Benedict Foreman, Montreat's first schoolteacher, is at the far right, wearing a weskit and skirt. Members of the Foreman family, as well as Cora Augusta Stone, are buried at Homer's Chapel in Black Mountain. Born in 1868, Stone was the valedictorian of Mount Holyoke College in 1889. During a missionary trip to Japan, she contracted tuberculosis. She then came to Montreat to recuperate in 1898, but she died in 1904. (PHC.)

This 1908 postcard predates the gate. Journey's Inn, the large two-story home at 119 Virginia Road, was built in 1903. Daniel Tompkins, the founder of the *Charlotte Observer* in 1892, purchased it in 1911, dying there a bachelor in 1914. Whispering Pines was built across the street at 120 Virginia Road by Carrie and Bertha Whallon. They founded the Montreat Orphanage, which was "set afire" in January 1905 by an orphan hoping for additional Christmas gifts.

This card wishes "A Merry Christmas" from Huyler's, maker of "unsurpassed bonbons and chocolates." John Seys Huyler made his fortune in the candy business, establishing chocolate factories and a chain of confectionary shops. A Methodist, he took Jacob's Pledge (Genesis 28:22), donating 10 percent of his income to charity. Huyler assumed much of Montreat's debt as it struggled financially, and also facilitated its purchase by individual Presbyterians from the South in 1906.

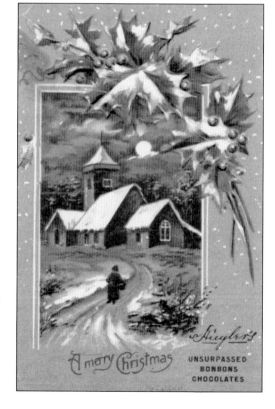

In 1900, Huyler built the wooden Montreat Hotel. Costing $20,000, it was a heated luxury hotel accommodating year-round guests. According to the June 13, 1906, *New York Daily Tribune*, "John S. Huyler of New York has invited one hundred churchmen to be his guests at the Montreat Assembly and will pay all their expenses." The hotel, which was also the first home of the Montreat Normal School (College) in 1916, burned in 1924.

Huyler belonged to the Black Mountain Rod & Gun Hunting Club. Rev. James Howerton, pastor of the First Presbyterian Church of Charlotte, was a friend of Huyler's and also an avid sportsman. Howerton led the movement to purchase Montreat as an assembly grounds for southern Presbyterians in 1906. Individual Presbyterians, mostly from the South, purchased stock in the Mountain Retreat Association for $100 per share to finance the acquisition.

David Warrington (far right), an elder of the Riverside Presbyterian Church of Jacksonville, Florida, purchased stock entitling him to two Montreat lots. In 1907, as it had been in 1898 under the Collins administration, lot selection was determined by drawing numbers. Warrington built his house in 1908 at 242 Texas Road, upon "The Rocks," beside a stream and waterfall. The house is still enjoyed by Warrington's descendants with the prayer "Deus Guardio Esta Casa."

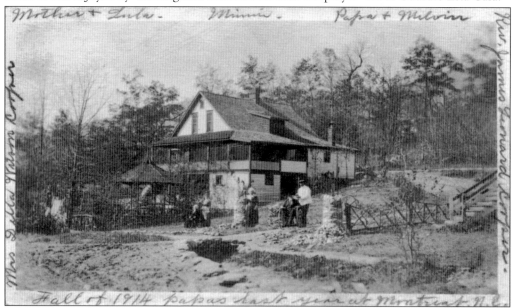

The note at the bottom of this card says, "Fall of 1914, papa's last year at Montreat, N.C." This building, known as the Piggery, was built at 231 Assembly Drive in 1902 by the Cooper family of Mississippi and Alabama. Inside the basement, a spring provided refrigeration. Outside were spring-powered jumping fish and other water-driven toys whittled by the Coopers. From left to right are "Mother" (Della Watson Cooper), Lula, Minnie, "Papa" (Rev. James Leonard Cooper), and Melvin.

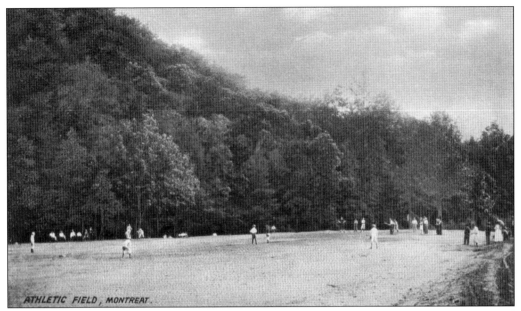

The baseball field was across the street from the Piggery. Players and spectators were invited to drink from the Coopers' spring. A pre-1906 Montreat marketing brochure proclaimed that soothing lithium waters flowed from this spring. As they did here in 1912, many still enjoy sports on what is now called Welch Field.

The Community Building, built in 1900 for $1,870.12, was a school, church, and auditorium. Charles Rowland of Athens, Georgia, the only Presbyterian among the original 15 founders, donated the funds for it. The Montreat Presbyterian Church was established there in 1906, with not a single Presbyterian among the 25 charter members. After serving as the social center for the African American community during the summer for decades, it now houses the Montreat post office.

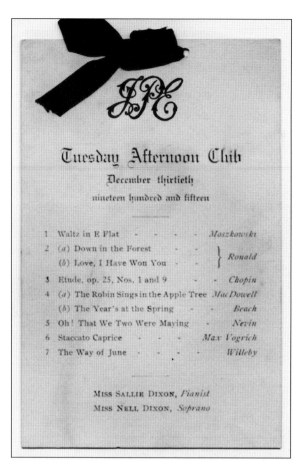

On December 30, 1915, the Tuesday Afternoon Club featured the works of composers Edward McDowell and Amy Beach, personal friends of Crosby and Dr. Juliette Adams, who moved from Chicago to Montreat in 1913. Juliette Adams was among the first to compose works specifically for beginning pianists, and both she and Crosby pioneered the introduction of music programs in public schools.

The Montreat post office was chartered on January 2, 1899. Frank Rood, a minister and livery owner, also served as the first postmaster, bringing both "the Word" and the mail to the community. The first post office building was opened on April 13, 1907, opposite the community building on the banks of Flat Creek. There has never been home delivery of mail in Montreat. (PHC.)

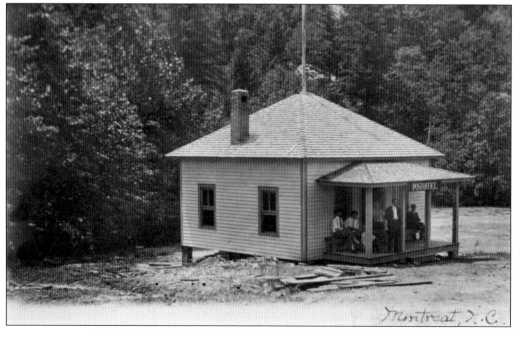

Montreat's social and commercial complex grew around the post office. Chester Case Lord, the first permanent resident of Montreat, served as postmaster from 1922 to 1932. He arrived in 1897 from New Haven, Connecticut, at the age of 41, after being given six months to live. He died at the age of 86. His daughter Dr. Margery Lord was North Carolina's first female health officer. The complex was demolished in the 1960s. (Robert Jones.)

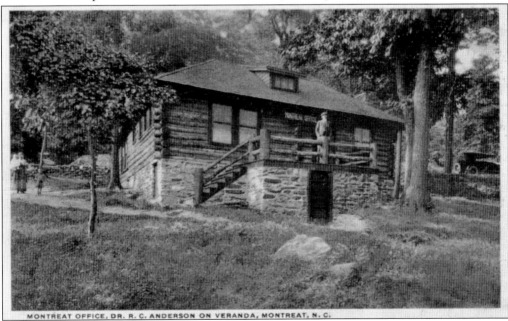

In 1911, Dr. Robert Campbell Anderson became the fifth president of Montreat. He retired 36 years later at the age of 83. He served as president and treasurer of both the Mountain Retreat Association and Montreat College. Dr. Anderson used this log cabin built by Anderson Kelly in the late 1880s as his office. From the veranda, as seen here, he could survey the buildings surrounding the lake.

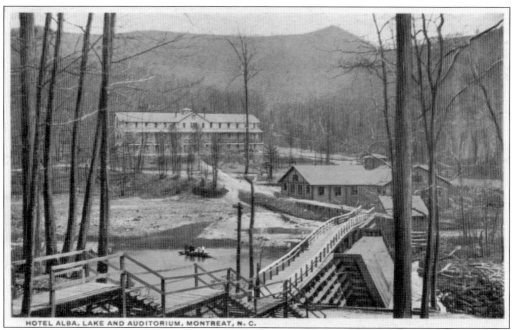

HOTEL ALBA, LAKE AND AUDITORIUM, MONTREAT, N. C.

In 1912, Dr. Anderson's view (above) included the large Alba Hotel, with dining for 400 but no heat, the tin-roofed Calvin Auditorium, where the voices of evangelists inspired conferees but could be drowned out by heavy rains, and the wooden dam, which impounded a three-acre lake but leaked. By 1930 (below), Montreat looked much as it does today. Clockwise from left were Dr. Anderson's log cabin office, the Assembly Inn (1929), the old Montreat Hotel annex (1900), the Lakeside Building (1925), the Boys' Club (1925), the Alba Hotel (1907), the Foreign Mission Building (1924), and Anderson Auditorium (1922). Always fundraising, Dr. Anderson was known as a "committee of one." A plaque on the grounds of Anderson Auditorium reads, "If You Seek His Monument Look Around."

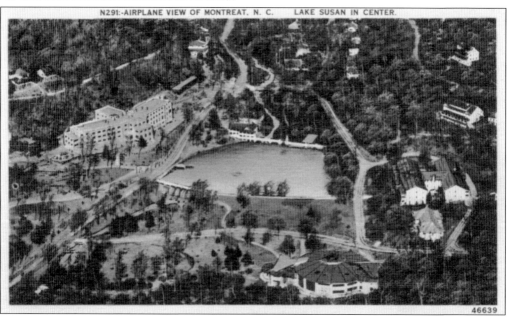

Anderson Auditorium was built by local men under the direction of Dr. Anderson and the supervision of Charles Godfrey of Black Mountain. Richard Sharp Smith was the architect of record. The first religious assembly was held in July 1897 near the present site of Howerton Hall, with 400 people attending for 10 days. Since 1922, the 2,500-seat Anderson Auditorium has hosted thousands of conferees each year. (Ron Nalley.)

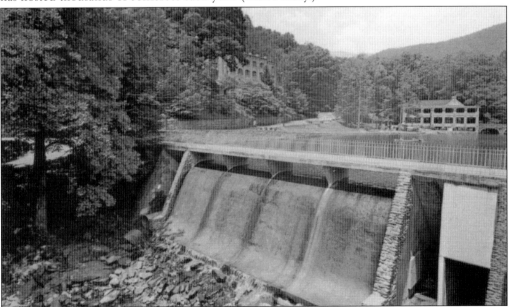

Lake Susan is the heart of Montreat. William Church Whitner, a South Carolinian and Montreat cottager, designed the original wooden dam, as well as the 1924 concrete dam donated by Susan Graham of Greenville, South Carolina, and Montreat. Four generations of Graham women were named Susan. A statue of Whitner stands near the courthouse in Anderson, South Carolina, commemorating his 1895 role in making Anderson the first electrified city in the South.

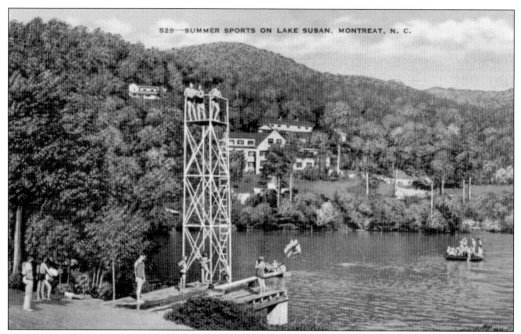

Swimming and stunts from the high dive were central to summer activities for generations. In the 1960s, a floating dock even proclaimed, "Please don't walk on the water." Swimming in Lake Susan ended around 1970. The growing number of homes in the community led to health concerns. The collective memory of all who swam in Lake Susan is, "No germ could possibly live in Lake Susan. It was too cold!"

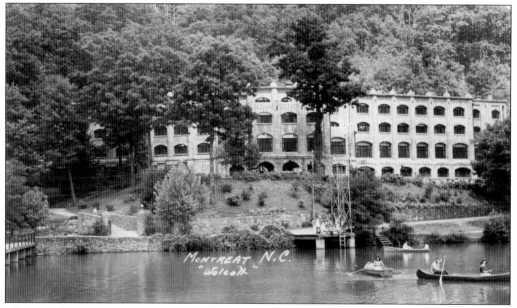

The Assembly Inn was completed in 1929. It stood atop the ashes of the Montreat Hotel overlooking Lake Susan, and only the wooden doors were flammable. In 1932, the *Charlotte Observer* called it the "Rainbow Hotel" for its sparkling mica-flecked stones and noted that the guests were "expected to attend religious services, and be awake when the collection basket comes along."

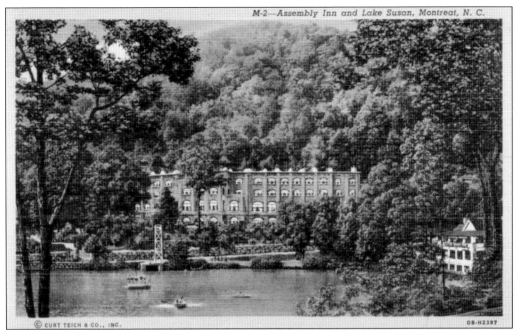

Boasting 130 rooms, the Assembly Inn housed conferees in the summer and Montreat College teachers and students in the winter. From October 29, 1942 to April 30, 1943, it housed a State Department official, 25 guards, and 264 Japanese and German civilian detainees stranded behind enemy lines when World War II broke out. Similar arrangements were made by the State Department with the Grove Park Inn and other luxury hotels.

Montreat netted $75,000 for housing the detainees. Of that money, $25,000 was reserved to build Spence Hall for the Presbyterian Historical Society. Built not of Montreat stone but of rock from the building of Highway 70 in 1954, Spence Hall (seen here) became the home of the Presbyterian Heritage Center in 2008. It features the wood carvings of John Mack Walker, which depict the gospels as told in the faces of the Appalachian people.

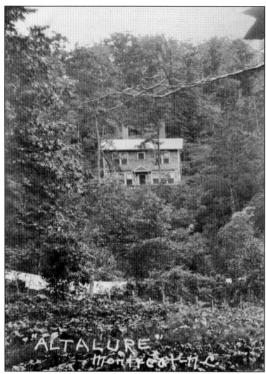

"Friends! Friends! Friends! / I have some friends I love / I love my friend and he loves me / I help my friend and he helps me." The original words of this beloved children's song were written in 1924 by Elizabeth McEwen Shields, the director of Children's Work for the PCUS Board of Christian Education from 1914 to 1936. She built her home, Altalure, at 343 Chapman Road in Montreat in 1933. (Peggy Hollandsworth.)

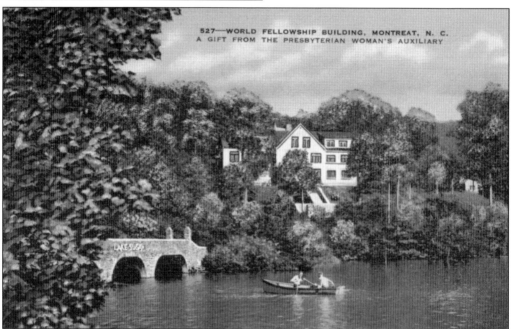

In 1938, the World Fellowship Building was built by the Woman's Auxiliary to house women from foreign lands. Renamed for Hallie Paxson Winsborough, it long housed Montreat College students during the school term and conferees to the Montreat Conference Center in the summer. Separate institutions since the mid-1970s, the Montreat Conference Center and Montreat College each have their own president and board of directors.

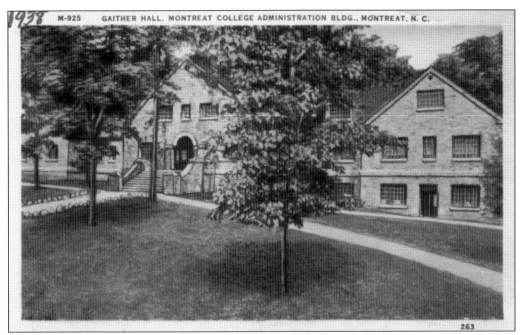

Gaither Hall, donated by Dr. Robert Anderson's wife, Sadie Gaither Anderson, was built for Montreat College in the 1930s. It included offices, classrooms, a library, and a chapel. Montreat College was founded as the Montreat Normal School in 1916. Gaither Chapel and the pews of Anderson Auditorium comprise some of the most extensive use of chestnut wood remaining in the South. The chestnut blight of the early 1900s decimated approximately 50 percent of the Montreat forest.

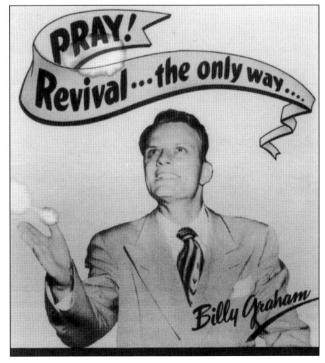

Evangelist William "Billy" Frank Graham Jr. met Ruth Bell, a student at Wheaton College, in 1940. They married in Gaither Chapel on April 13, 1943, holding their wedding reception at the Assembly Inn. Bell was born in China, the daughter of Dr. Nelson and Virginia Bell, Presbyterian missionaries and Montreat residents. As Reverend Graham shared his ministry with the world, he and Ruth made Montreat their family home. (Maury Scobee.)

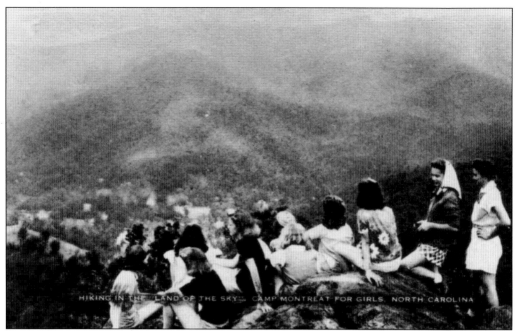

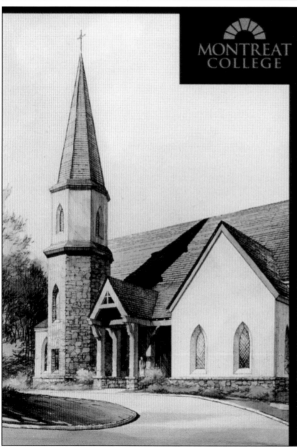

Camp Montreat for Girls was founded in 1925 by Dr. Anderson and William Henry Belk, the founder of Belk Department Stores, on 28 acres near Lookout Road. Here, Betty Jeanne Ellison (later known as BJ Candler, wearing the scarf) and fellow campers enjoy the view from Lookout Mountain in 1942. Camp Montreat closed in 1967. "Macky" McBride, the director of Camp Montreat from 1933 to 1950, left to open Camp Merri-Mac on Montreat Road in 1950.

The Chapel of the Prodigal was dedicated on the Montreat College campus in 1998. It was designed to incorporate the fresco *Return of the Prodigal* by artist Benjamin Franklin Long IV into its wet plaster walls. The work is one of 11 frescoes that can be viewed on the Ben Long Fresco Trail in North Carolina. The story of the Prodigal Son is told in the New Testament, Luke 15:11–32.

Five

The North Fork Valley
North Fork Valley, Black Mountain College, and Mount Mitchell

Frederic Burnet made his way to the upper North Fork Valley around 1790. Robert and Jeannie Ingram settled in the lower North Fork in 1799. Joined by other pioneer families, the community, located in the shadow of the Craggy and Black Mountains, flourished. By the 1850s, it consisted of more than 50 families and had two churches, a law school, and boardinghouses for tourists making excursions to Mount Mitchell.

Botanist André Michaux came in the 1790s, identifying and sending "exotic" native plants back to France. Dr. Elisha Mitchell, a Presbyterian minister and professor, came to measure the mountain peaks and fell to his death on his final quest in 1857. Zebulon Baird Vance, a North Carolina governor and US senator, built his summer home at the foot of the mountains in the 1880s. In 1921, North Fork native and attorney Lillian Exum Clement became the first woman elected to the North Carolina Legislature. In 1923, the Mountain Orphanage, now known as the Black Mountain Home for Children, relocated to Lake Eden Road. It was established in 1904 and is the oldest orphanage in Appalachia. In 1941, Black Mountain College moved to its Lake Eden campus, the site of Buckminster Fuller's first geodesic dome. The college closed in 1956, but the administrative building known as "the Ship," built by the college, remains at Camp Rockmont.

The North Fork of the Swannanoa River springs from two sources high in the mountains. The left and right forks of the North Fork of the Swannanoa River merge at what is known as "the Confluence," partway down the valley, before continuing their flow towards Asheville and the French Broad River. With the coming of the railroad to nearby communities, the population of the North Fork Valley declined. In 1903, the City of Asheville began accumulating property in the North Fork for the water needs of its bourgeoning population. The Burnett Dam was built in 1953. The river was tamed, the Mountain View Baptist Church and its cemetery were relocated by its members, and a way of life was gone forever.

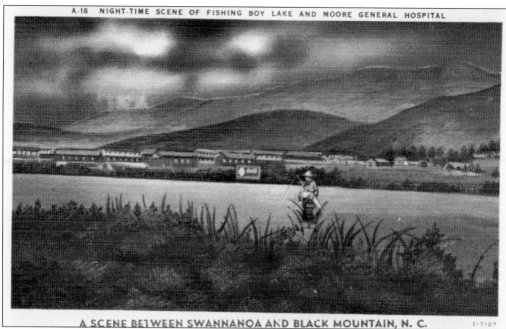

Fishing in a "borrow" pond between the Grove Stone & Sand Company and Moore General Hospital, the "Coca-Cola Boy" advertising sign marked the entrance to the North Fork Valley in the 1940s and 1950s. Area youth ice-skated "with him" in the winter months. The quarry was incorporated on January 26, 1924, by Dr. Edwin Wiley Grove to provide building materials for his many building projects, including Swannanoa's Grovemont housing development and Asheville's Grove Arcade.

Presbyterians Robert "Bobbie" Ingram, of County Down in Ireland, and his wife, Jeannie, of Virginia, were the first settlers in the lower portion of the North Fork. They made their first purchase in 1799, and they owned 1,122 acres by 1834. The original homestead where the couple farmed and raised their eight children was near what is now Lake Eden.

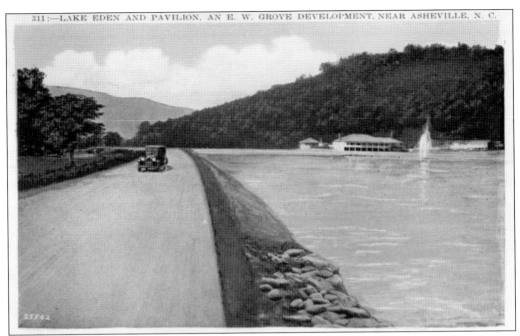

The Ingram homestead was sold by the descendants of the Ingrams to E.W. Grove in the 1920s. Grove built a small lake, a country club, and recreational facilities on the property that were designed to serve the residents of the nearby Grovemont housing development.

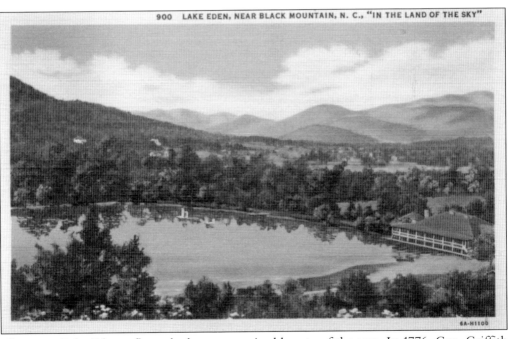

The name Lake Eden reflects the long-recognized beauty of the area. In 1776, Gen. Griffith Rutherford led 2,400 Revolutionary soldiers through the Swannanoa Valley campaigning against the Cherokees, who had sided with the British. Rutherford called the valley "Eden Land."

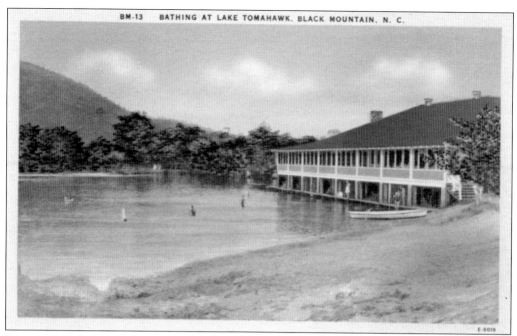

Incorrectly titled "Bathing at Lake Tomahawk, Black Mountain, N.C.," this very popular and commonly found postcard actually shows a view of the dining hall and swimming pavilion built at Lake Eden by E.W. Grove in the 1920s.

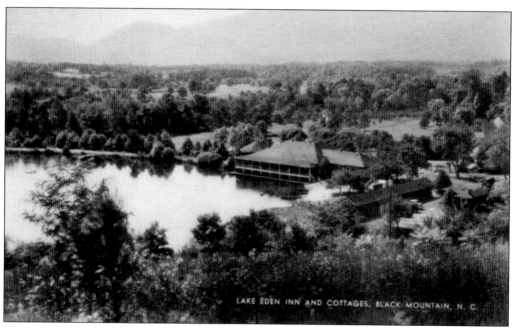

Black Mountain College was founded in 1933 at the YMCA Blue Ridge Association. The location was suggested by Robert Wunsch, a drama coach at Rollins College who was also briefly a roommate of novelist Thomas Wolfe at the University of North Carolina. At $4,500, the rental price was good, but college operations were limited to the winter months. In 1937, the college purchased the Lake Eden property for a permanent campus.

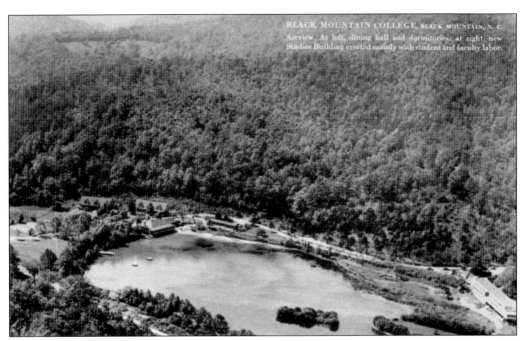

The 667-acre Lake Eden property was purchased for $35,000. It had a large dining hall, two lodges, and several guest cottages. These early buildings can be identified by their stone foundations. Before moving from Blue Ridge in 1941, students and faculty ran the resort for two summers, built a new studies building, and winterized the existing structures. Charles Godfrey of Black Mountain supervised the construction.

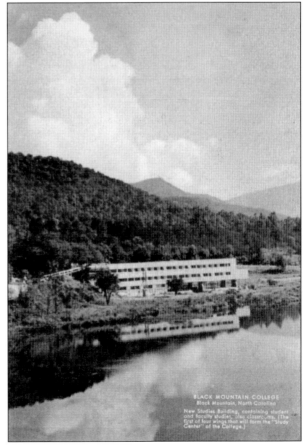

Still standing and called "the Ship," the studies building housed classrooms and studios. The college fostered experiential learning. Students designed their own course of study and were involved in the daily decisions and work required to run the college. There were no formal courses or grades, and few actually graduated. Faculty members included artist Josef Albers of Germany's Bauhaus movement and poet Charles Olson. Albert Einstein also publicly supported the college.

Summer Institutes began in 1944, and the student body grew with the advent of the GI Bill. In 1948, Buckminster Fuller built his first geodesic dome on the campus, using venetian blinds. Other summer faculty included artists Willem de Kooning and Robert Rauschenburg, composer John Cage, and modern dance pioneer Merce Cunningham. The first "happening" in performance art occurred in the college dining hall in 1952.

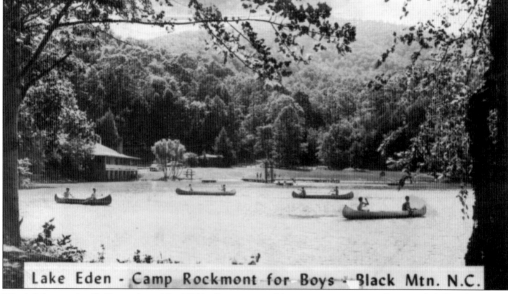

Black Mountain College closed in 1956 after succumbing to ever-present financial difficulties and internal strife brought about by the dysfunctional governing style of "leadership by consensus." In 1956, George Pickering purchased the property and opened Camp Rockmont for Boys. The Camp Rockmont campus houses the Learning Community School (K–8) during the academic year and also hosts the twice-yearly Lake Eden Arts Festival (LEAF).

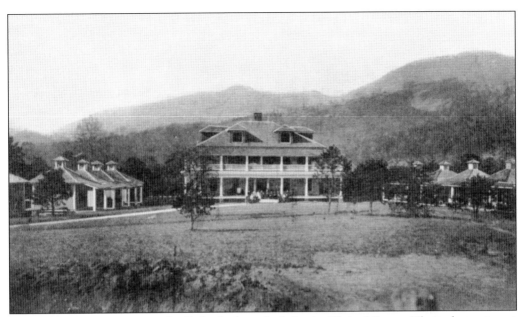

In 1900, about 100,000 people died of tuberculosis in the United States. The only treatment was rest and fresh air, and, even then, a diagnosis of TB was often considered a death sentence. Because it had a healthy climate and could be accessed by rail, public and private sanatoriums were built across Western North Carolina. The Royal League Sanatorium was built in the North Fork Valley in 1904. It was privately funded by the Royal League Fraternal Order of Chicago.

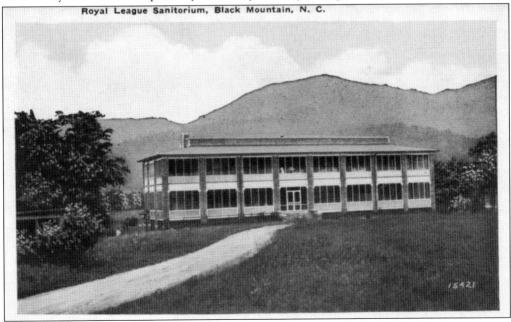

The wooden Royal League Sanatorium burned in 1919 and was replaced by this two-story masonry building with large sleeping porches. The sanatorium closed its doors in 1945, and the property was purchased in 1958 by the African Methodist Episcopal Church under the leadership of Bishop William Jacob Walls. It is now the Camp Dorothy Walls Conference Center, named after the bishop's wife. (SVM.)

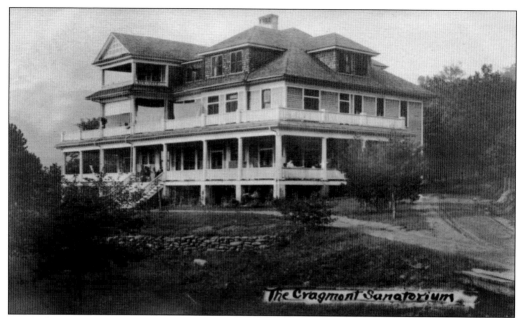

Cragmont Sanatorium was built in 1923 as a public facility. Dr. Isaac J. Archer, originally from Chicago and a resident of Montreat, was the medical director of both Cragmont and the Royal League. Each sanatorium housed 25–30 patients. After World War I, Cragmont also housed soldiers exposed to mustard gas. Original Free Will Baptists purchased the property in 1945, established Cragmont Assembly, and eventually demolished the wooden sanatorium.

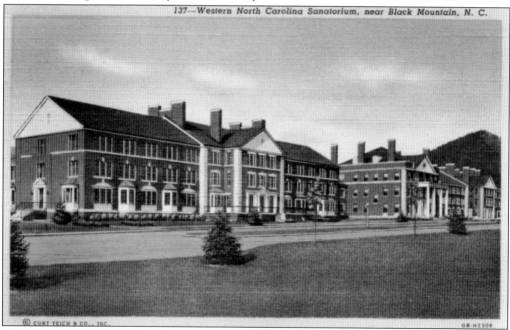

The Western North Carolina Sanatorium opened in 1937. With better treatment available at the state-funded facility, small, privately run sanatoriums were no longer needed. Following the chance discovery of penicillin by Alexander Fleming in 1928 and the realization of its lifesaving properties in the 1940s, the state facility itself was no longer needed to treat tuberculosis.

Once larger than Asheville, the North Fork Valley was home to a thriving community in the 1850s and early 1900s. The Mountain View Baptist Church was founded in 1828; its original location is now submerged by the Burnett Reservoir. The Methodist Tabernacle Church and School was founded in 1837. Judge John Lancaster Baily ran a law school alongside the route to Mount Mitchell from 1859 to 1861.

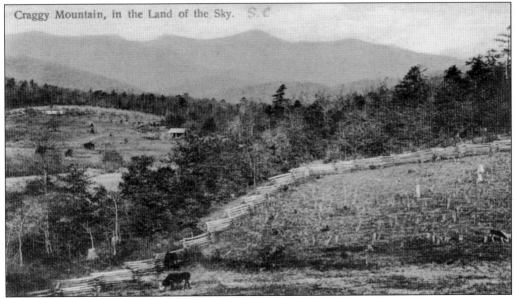

Settlers living at the base of the Craggy Mountains were largely self-sufficient, clearing the land for their livestock and crops. Farming, logging, and bear hunting were a way of life. Oden Walker recalled early days in the North Fork in his 1950s column "Bittersweet" in the *Black Mountain News*. Family names included Ingram, Stepp, Cordell, Burnett, Walker, Patton, Bartlett, Allison, Gragg, Morris, Connally, Tyson, and Vance.

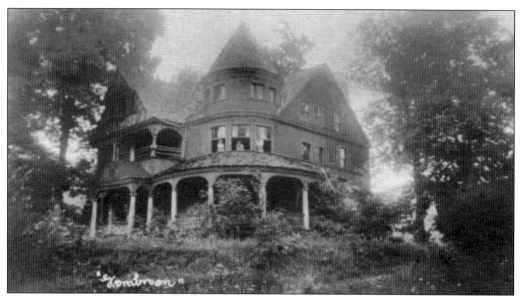

Gombroon, meaning "imaginary empire," was the summer residence of Civil War hero, North Carolina governor, and US senator Zebulon Vance and his second wife, Florence Steele Martin. A wealthy widow, she purchased 1,500 acres for $5,000 as an investment for her son. In 1883, she built this Tudor-style mansion using local labor and timber. Part of the Asheville watershed, it was sitting empty when it mysteriously burned on September 12, 1936, reportedly struck by lightning on a clear day. (SVM.)

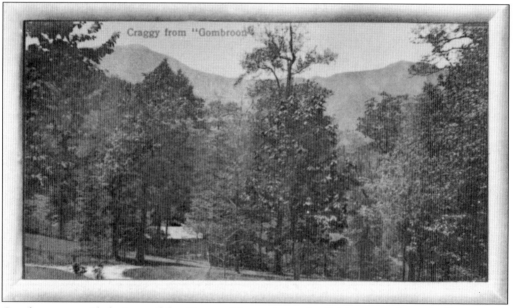

Gombroon provided views of the Craggy Mountains and a fishing spot along the Swannanoa River for Senator Vance, an avid outdoorsman. Active in the community, the Vances attended church and social events and provided work for the locals, paying as much as 80¢ for a 10-hour day to build a mile-long, four-foot-wide, four-foot-high stone wall bordering the approach to the house.

A North Fork native and the daughter of George and Sarah Clement, Lillian Exum Clement Stafford (1894–1925) was admitted to the North Carolina Bar in 1917 and became the South's first elected female state legislator in 1921. She won her seat in the North Carolina House of Representatives by a vote of 10,368 to 41, successfully introducing bills requiring secret ballots and voting booths. Women gained the vote on August 18, 1920. North Carolina ratified the 19th Amendment in 1971.

Asheville began acquiring land in the upper North Fork Valley to provide water for its growing population in 1903, purchasing 4,700 acres from William Patton. The watershed lands are now approximately 15,000 acres. Some families sold willingly; others were forced to leave. The first water intake was built in 1903, and the Burnett Dam was built in 1953.

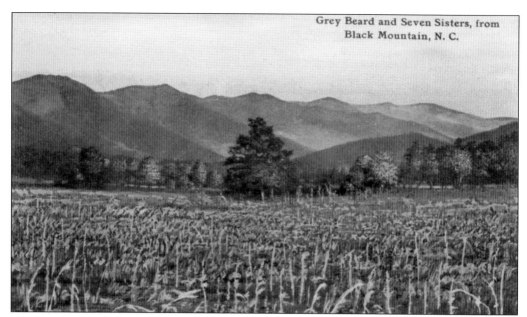

Grey Beard and Seven Sisters, from Black Mountain, N. C.

Walkertown Ridge forms the eastern boundary of the Walkertown community and the North Fork Valley. Walkertown stretches from the Mountain View Baptist Church to the Burnett Reservoir and is named for the many descendants of Jonathan and Sarah Walker, settlers in the early 1800s. Montreat lies on the other side of the ridge. Some call the peaks the "Seven Sisters," while official maps call them the "Middle Mountain."

Through the Primitive Forest, on the trail to Mitchell. "In the Land of the Sky."

For over 200 years, the Craggy and Black Mountains have been recognized for their plant diversity and rugged mountain peaks. French botanist André Michaux collected botanical specimens in the Black Mountains in 1789 and 1794. In 1835, 1838, and 1844, Dr. Elisha Mitchell, a Presbyterian minister and professor of chemistry and geology at the University of Chapel Hill, led expeditions to measure the elevation of Western North Carolina's mountains.

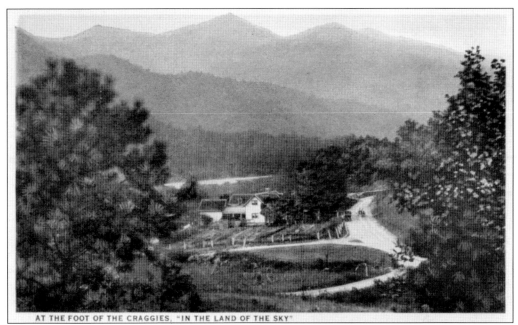

AT THE FOOT OF THE CRAGGIES, "IN THE LAND OF THE SKY"

Sophronia Burnett Walker was the first white woman to climb Mount Mitchell, ascending the mountain with her husband, James, and Dr. Elisha Mitchell. Julius Walker, one of her 12 children, built this home on the right fork of the North Fork of the Swannanoa River in 1887. In 1926, his daughter Maude Walker Morris acquired the home. Still occupied by family members today, it looks much the same as when it was built.

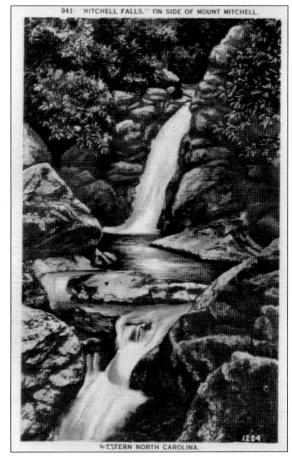

941: "MITCHELL FALLS," ON SIDE OF MOUNT MITCHELL.

WESTERN NORTH CAROLINA.

In 1857, Mitchell and US Sen. Thomas Clingman were engaged in a bitter scientific feud with political overtones. Mitchell, a Whig, and Clingman, a pro-secession Democrat, each claimed to have been the first to measure the tallest peak in the Black Mountains. Mitchell fell to his death on a solitary expedition to validate his claim. His body was found at the bottom of a waterfall following a massive 10-day search.

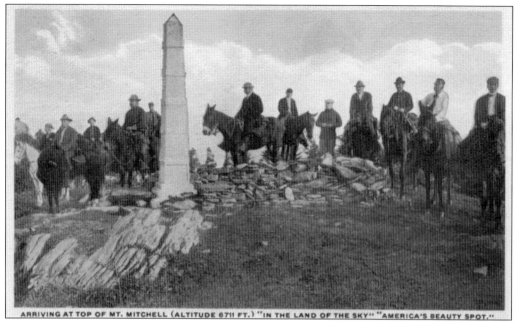

Mitchell was first buried in the cemetery of the First Presbyterian Church of Asheville. On June 16, 1858, he was reinterred at the top of Mount Mitchell. This monument, surrounded by horsemen, marked his grave from 1888 to 1915. Jesse Stepp, a guide in the North Fork, and his wife, Adeline, donated five acres on the mountain for his burial site. Mitchell had spent his final night at the Stepp guesthouse before beginning his ascent.

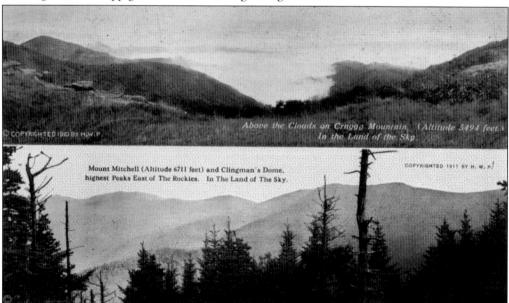

In the 1840s, William Patton of Charleston, South Carolina, purchased 5,000 acres in the upper North Fork. On July 13, 1854, Patton opened the Mountain House. At an elevation of 5,200 feet, it provided a welcome final way station for wealthy travelers, even offering champagne and salmon. Mitchell passed by the Mountain House on his fatal journey on June 27, 1857. The outbreak of the Civil War precipitated its closure.

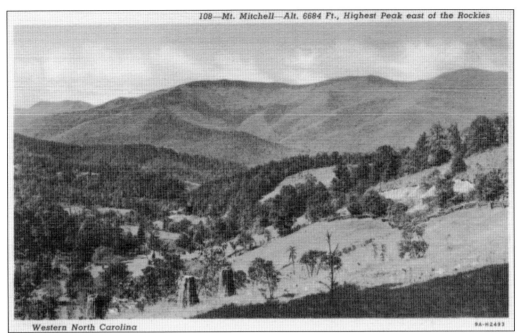

Early measurements of Mount Mitchell's elevation varied, as they were dependent upon weather-sensitive barometric readings and complicated mathematical calculations. The correct elevation of 6,684 feet above sea level is noted on this 1939 postcard. However, Mount Mitchell is not the highest peak east of the Rockies. That distinction belongs to Harney Peak, elevation 7,244 feet, in the Black Hills of South Dakota. Mount Mitchell is the highest peak east of the Mississippi.

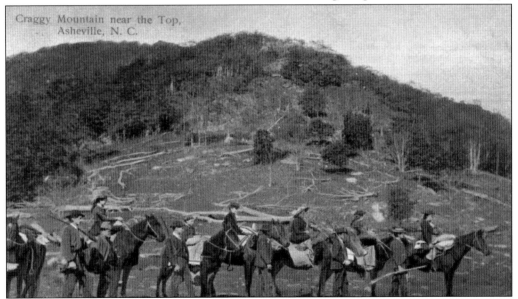

Until the addition of passenger cars to the Mount Mitchell Logging Railroad in 1913, the most direct route to the Craggy and Black Mountains from the south was through the North Fork Valley. Tourists made the steep ascent on foot or on horseback, often hiring guides for the rugged journey. The peaks in the Craggy Mountains top 5,000 feet, and most in the Black Mountains top 6,000 feet above sea level.

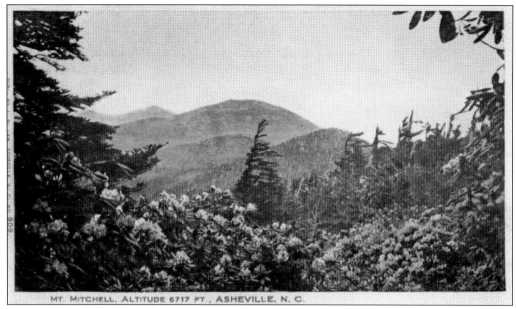

One of the earliest views of Mount Mitchell, this photograph was published in *Lindsey's Guide Book to Western North Carolina* in 1890. It was then made into postcards as early as 1906. Thomas Lindsey and Edward Brown had a photographic parlor in Asheville in 1890 offering portraitures and views of Western North Carolina, which was described as "the Poet's Dream" and "the Health Seeker's Paradise."

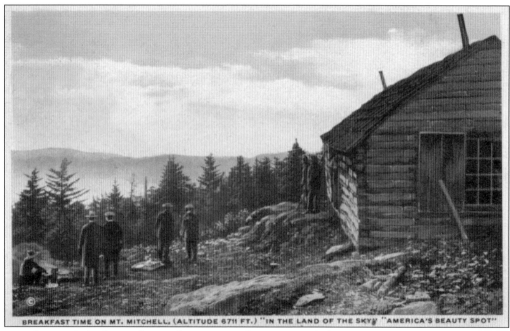

Travelers in 1911 who made it to the summit of Mount Mitchell could enjoy sunrise and breakfast in "The Land of the Sky, America's Beauty Spot." The writer of this postcard related that he "enjoyed a fine morning after experiencing a thunderstorm during the night."

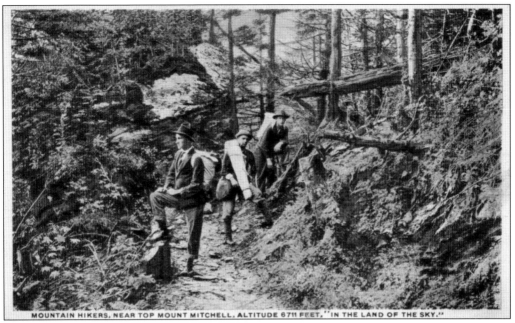

Early hikers made their final way to the top of Mount Mitchell through stands of red spruce and Fraser fir. The Black Mountains get their name from the dark color of these evergreen trees. During World War I, the spruce and fir, with their lightweight yet strong wood, were highly prized for building aircraft for the fledgling US Army Air Service.

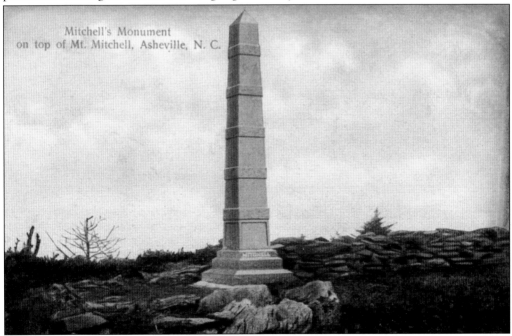

Multiple observation towers have been built atop Mount Mitchell. In 1915, the 12-foot hollow bronze monument dedicated to Dr. Mitchell was destroyed by unknown causes. One theory suggested it fell victim to weather and damage from tourists carving their names on its surface. Another largely discounted theory suggested it was dynamited by disgruntled loggers.

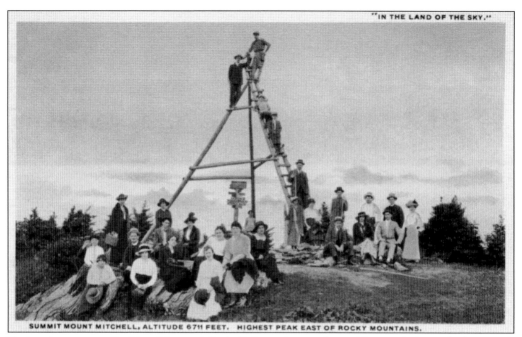

Early adventurers climbing Mount Mitchell from the south could ascend through the North Fork Valley. After 1903 and the creation of the Asheville watershed, hikers used the Montreat trails. Hikers and passengers on the Mount Mitchell Railroad could enjoy the mountain views from Mount Mitchell's first observation tower, built around 1915.

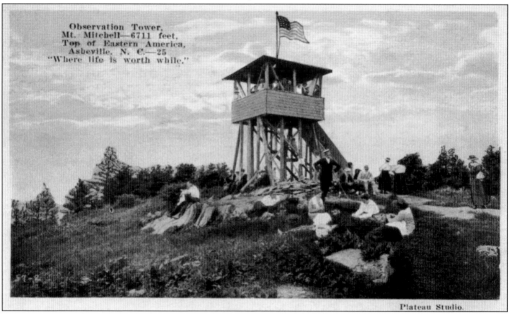

Postmarked 1923, this card showing a platform observation deck built by the railroad was published by Plateau Studio, the studio of George Masa. An enigmatic immigrant from Japan, Masa worked at the Grove Park Inn and became a noted photographer. He went on to found the Carolina Mountain Hiking Club and, along with Horace Kephart, was instrumental in the creation of Great Smoky Mountains National Park.

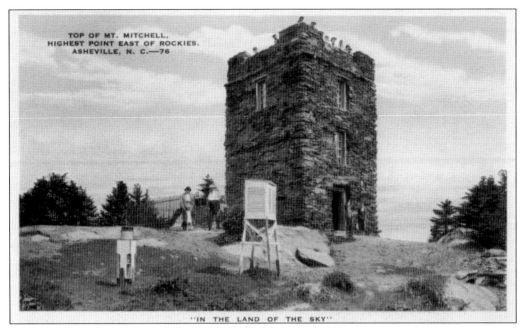

From 1926 until 1959, visitors climbed a castle-like stone tower to see expansive mountain views across five states: North Carolina, South Carolina, Tennessee, Georgia, and Virginia. Dr. Elisha Mitchell's grave and a government weather station were at the base. Since 1959, two additional observation towers have been built. A 30-foot tower ringed by an observation deck was replaced in 2009 by a handicapped-accessible circular structure 10 feet high.

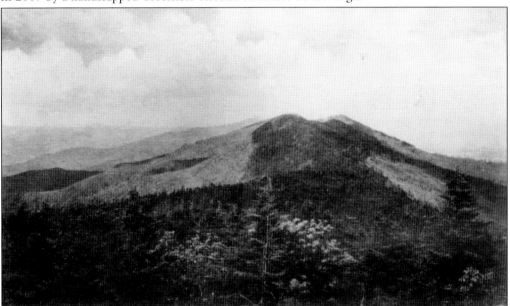

Thousands of acres of virgin forests were logged in the 1910s and 1920s. This 1926 postcard looking from the top of Mount Mitchell towards the Black Mountains shows the massive clear-cutting. Alarmed by the rapid deforestation, Mount Mitchell State Park was established in 1915 by Gov. Locke Craig (1913–1917), a resident of Buncombe County who was well known to North Fork lumbermen. Mount Mitchell was the first state park in North Carolina.

The Blue Ridge Mountains, forming the eastern boundary of the Swannanoa Valley, can be seen as one looks southeast from the tower. The ghost trees in the foreground at the summit are Fraser firs that have been killed by the balsam woolly adelgid (*Adelges piceae*). The insect was introduced into the United States in 1908 and reached the Mount Mitchell spruce and fir ecosystem in the 1960s.

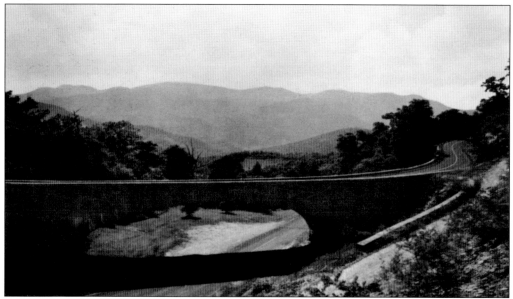

The opening of the Blue Ridge Parkway in 1939 provided easy public access to Mount Mitchell by automobile. Mount Mitchell is seen in the background in this view, taken from Buck Creek Gap. The mountain is characterized by a long, broad peak rather than a sharp peak, and it is sometimes difficult to distinguish, as there are more than 12 peaks above 6,000 feet in the Black Mountain Range.

Six

Swannanoa Township
Swannanoa, Bee Tree, Warren Wilson, and Riceville

Swannanoa Township includes the communities of Swannanoa, Bee Tree, Warren Wilson, and Riceville. It is bounded on the east by Lake Eden Road, just west of the town of Black Mountain. Gudger's Bridge, near Oteen on Highway 70, marks its western boundary, near the Asheville city limits. After the Revolutionary War, the Swannanoa Settlement was one of the first European communities west of the Blue Ridge Mountains.

Samuel Winslow Davidson and his family were the first settlers in the valley, leaving their home in Davidson's Fort (Old Fort) in 1784 and building a cabin at the base of Jones Mountain near Christian Creek. Only a few months later, Davidson was lured to his death by an Indian hunting party. His wife, Rebecca, their infant daughter Ruth, and a female servant fled the 18 miles back to Davidson's Fort. Davidson was buried on Jones Mountain by friends and family, including his twin brother William, who came to avenge his death. Many returned, establishing the Bee Tree (renamed Swannanoa) Settlement in 1785 at the confluence of Bee Tree Creek and the Swannanoa River. Rebecca Davidson, remarried to a member of the Alexander family, also returned to the valley. The Robert Patton Meeting House was organized in 1794. It is now the First Presbyterian Church of Swannanoa.

In August 1815, Davy Crockett married Elizabeth Patton of the Swannanoa Settlement. In 1894, Warren Wilson College was founded as the Asheville Farm School by the Northern Presbyterian Church. The late 19th century was defined by the arrival of the railroad in 1880, and the 20th century was defined by the arrival of the Beacon Manufacturing Plant in 1925, which provided employment and a way of life for more than seven decades. Dr. L. Nelson Bell, a former missionary to China and the father of Ruth Bell Graham, served as the Beacon physician in the 1940s. Joseph Miller Rice, the namesake of Riceville, settled near Bull Gap in the 1780s, establishing a drover's station for hogs and turkeys being driven from the mountains to markets along the coast. The last buffalo in the Swannanoa Valley was reportedly killed near Riceville around 1800.

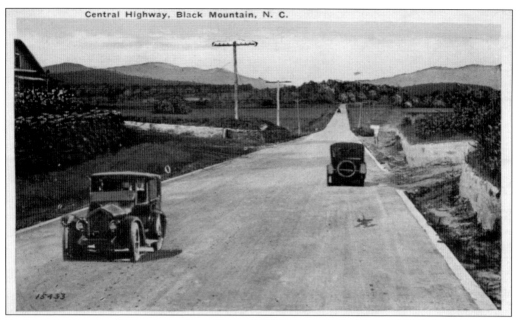

Early motorists traveling westward on Central Highway passed through Black Mountain into Swannanoa. In 1911, the North Carolina Legislature authorized the construction of Central Highway to connect the coastal and mountain regions. In the 1910s, it became Route 10. The Federal Aid Highway Act of 1925 established a nationwide standardized numbering system, and, in 1927, it was designated Highway 70, following much the same path as Route 10.

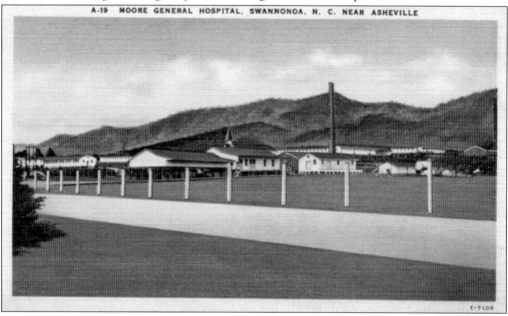

With wartime urgency, the construction of Moore General Hospital and its 118 buildings and 36 barracks began in May 1942 and was completed in four months. It received soldiers from the European, North African, and Pacific fronts, and the first patients arrived in November. Located on 200 acres just west of Lake Eden Road, the railroad was extended to bring the wounded directly into the compound. Col. Frank W. Wilson was the commanding officer.

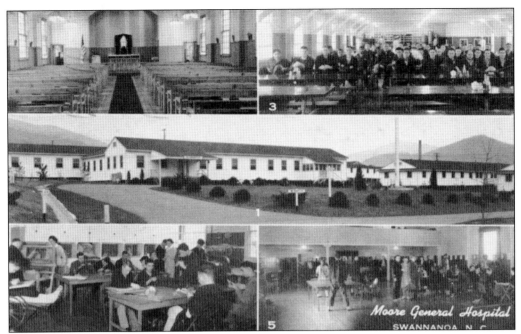

Moore General Hospital was built to treat 1,520 patients and was home to the Army's Tropical Disease Center. Over 1,600 service members and 500 civilians were on staff. Housing and support facilities were built to accommodate their needs. In 1945, a group of 250 German prisoners of war arrived to augment the workforce. Eleanor Roosevelt visited the hospital, Black Mountain College, and Montreat in July 1944.

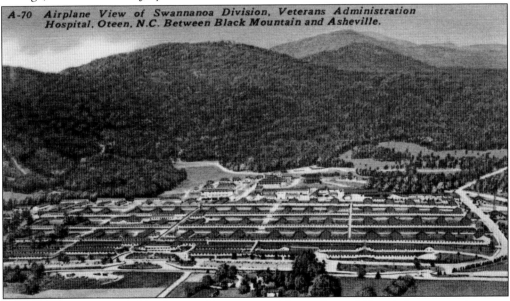

In 1946, no longer needed by the War Department, Moore General Hospital was turned over to the Veterans Administration for the treatment of tuberculosis patients. Lt. Commander Frank Wade served as the civil engineer. In 1961, the Veterans Administration deeded 162 acres and over 500 buildings to the State of North Carolina for use as a juvenile evaluation and detention center. The Swannanoa Correctional Center for Women opened at the site in 2008.

Marie Cromer Seigler, a native of Abbeville, South Carolina, founded the Girls' Tomato Club in 1910. Along with the Boys' Corn Clubs of the early 1900s, it was among the forerunners of the National 4-H Club, established by Congress in 1914. One of the first organizations providing activities for both girls and boys, the 4-H Club's motto is "To Make the Best Better." The four Hs stand for head, heart, hands, and health.

The Swannanoa 4-H Camp opened in June 1929, following the completion of the main building. The first 4-H camp in North Carolina, it was built through the combined efforts of the community and the state on 12 acres of the State Test Farm. Buncombe County built the roads, private businesses donated funds, and individual county 4-H clubs raised funds for sleeping cabins. Some clubs sold chickens and eggs to raise the necessary funds.

Early campers paid $1 to attend, brought their own food, and were taught table manners, canning, sewing, tree identification, and camp crafts. During World War II, the cabins were torn down and barracks were built to house German prisoners of war. The barracks are gone, but a stone patio and two large rooms that were added to the main building by the German officers still remain. The camp ceased operation in 2013.

George and Elizabeth Alexander built Alexander's Inn in 1820, raising their six children there and hosting travelers, including US Sen. Henry Clay. The oldest building in the Swannanoa Valley, seen here in the 1910s, it is still occupied by descendants of George and Elizabeth Alexander. In 1949, it ceased operation as an inn after more than a century of hosting visitors to Swannanoa. (Bill Alexander.)

Looking towards Black Mountain in 1915, the train can be seen pulling into the Swannanoa station. Allen Mountain is in the background. The two-story structure in the foreground, Parks Boarding House, provided rooms for railroad workers and tourists. Swannanoa High School graduated seven girls and four boys in 1911. The class motto was a Mark Twain quote: "It's better not to know much than to know so many things that ain't so."

Wallace Mann graduated from the National Business College in Roanoke, Virginia, on May 24, 1920, with a degree in banking. Monthly reports were sent to G.A. Mann of Swannanoa to document Wallace's attendance, deportment, and academic progress. Private mailing cards, authorized by an act of Congress on May 19, 1898, and costing 1¢ postage, were an efficient and cost-effective method of communication for businesses of the time.

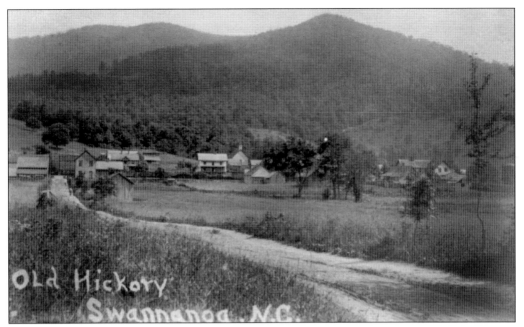

In 1895, residents requested the North Carolina Railroad Commissioners change the railroad station's name from Coopers to Swannanoa. The designation "Old Hickory" may refer to Highway 10, which was proposed to connect coastal North Carolina with Tennessee. Pres. Andrew Jackson, nicknamed "Old Hickory," was born in the sparsely settled and un-surveyed Waxhaw area between North and South Carolina but lived in Tennessee.

Norfolk & Western Locomotive No. 1218 is seen here steaming through Swannanoa on a special excursion on July 23, 1989. Some 66 years earlier, in 1923, Charles Dexter Owen II of New Bedford, Massachusetts, traveling by rail through Swannanoa, saw flat, vacant land adjacent to the track. In search of a cheaper labor force in the South, he deemed Swannanoa the perfect place to relocate his New England textile plant, Beacon Manufacturing.

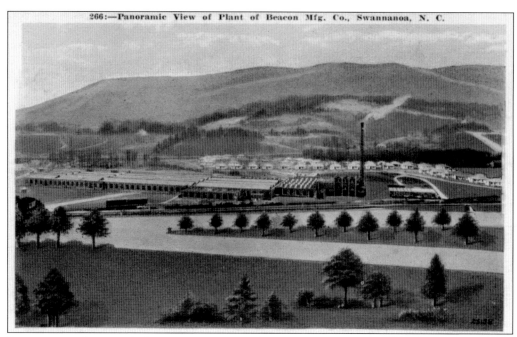

Beacon Manufacturing's slogan was "Beacon Blankets Make Warm Friends." After purchasing the 42-acre Whitson farm between the railroad and the river, Charles D. Owen II moved his Massachusetts plant "brick by brick" to Swannanoa. Manufacturing began in 1925. During World War II, the plant produced blankets solely for the armed forces. At its peak, Beacon was the largest manufacturer of blankets in the world, employing 2,200 workers, running three shifts a day five days a week so it could shut down on Saturdays and Sundays. A village grew around the mill, and, while the "old village" of 32 single-family homes remained on the river side, the "new village" of 27 duplex homes was built on the railroad side. Rent was 25¢ per room, and boardinghouses accommodated additional workers. Multiple generations worked in the plant and lived in the village, which had its own stores, churches, and doctors. After multiple changes in ownership, the plant was closed in 2002 and destroyed by fire on September 4, 2003.

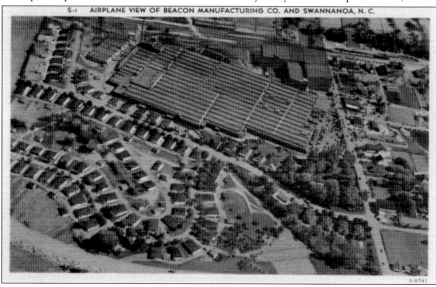

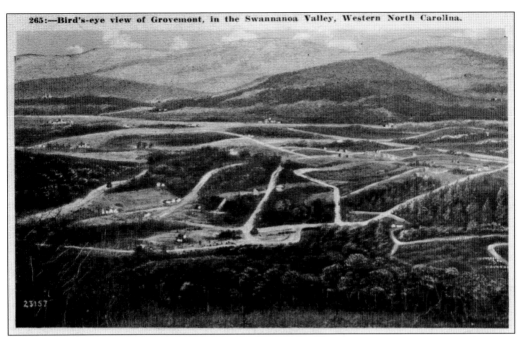

Built by Edwin Grove in the 1920s, Grovemont-on-Swannanoa provided housing for Beacon Manufacturing executives. It was the first planned housing development in the United States. The development included 19 homes built in the English style, 16 of which remain today. St. Margaret Mary Catholic Church was dedicated on October 11, 1936. It was needed because many Beacon executives relocating from Massachusetts were Catholic, and the nearest Catholic church, St. Lawrence, was 20 miles away in Asheville.

Carrie Davidson Alexander, then the owner of Alexander's Inn, sold the 275-acre property for Grovemont to Edwin Grove in 1918 to provide college educations for her children. The nearby Lake Eden Country Club, the site of Black Mountain College and now Camp Rockmont, in the North Fork Valley, was built as a recreational complex for Grovemont residents. (Bill Alexander.)

Suffering from bronchitis and chronic hiccups, Edwin Grove came to Asheville for his health in 1897. An entrepreneur, he made his fortune developing and selling Grove's Tasteless Chill Tonic, a quinine elixir that was effective against malaria. Turning to real estate, he built Asheville's Grove Park Inn in 1913, in just 11 months and 27 days. The Grovemont housing development, among his last projects, was never finished. Grove died in 1927.

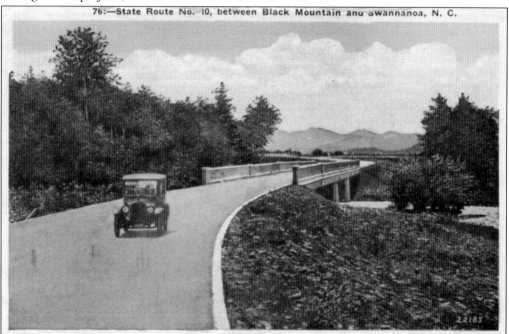

Continuing towards Asheville, one follows along the meandering Swannanoa River, where frontiersman Davy Crockett married Elizabeth Patton in 1815. Elizabeth's first husband, James, was killed fighting alongside Crockett in the Creek War. Crockett died at the Battle of the Alamo in 1836. A monument marks Elizabeth's 1860 burial site in Acton, Texas. At .006 acres, it is the smallest state park in Texas.

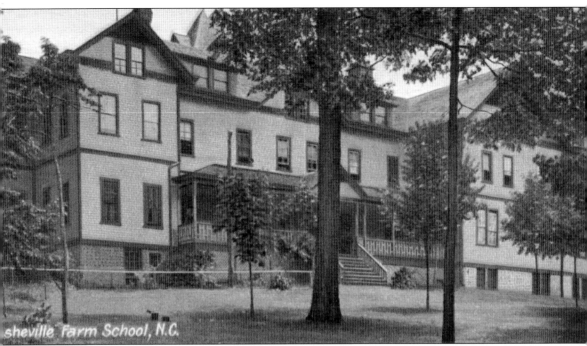

The Asheville Farm School was founded in 1894 by the Women's Board of Home Missions of the Northern Presbyterian Church to provide education to mountain boys. They sold shares at $10 per share to fund the enterprise, purchasing the 72-acre Sherill tract and the 378-acre Davidson farm for $14,500. It opened in 1895 with three teachers and 25 young men in their teens and 20s. The first curriculum covered only up to third grade. The first high school class graduated in 1924. Students worked on the farm to cover tuition. In the 1920s, wages and tuition were weight dependent. Larger students were paid more, as they could do heavier work, but their tuition was higher, as they ate more. The original Farm School building, along with many early records and other facilities, burned in December 1914.

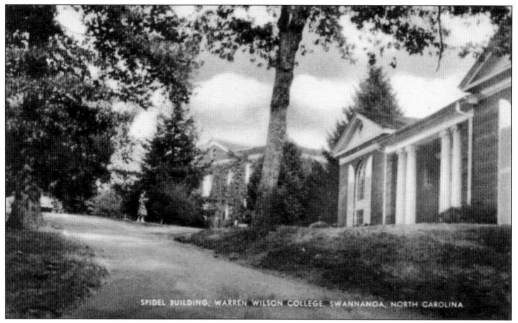

Beset by financial worries, the institution was strangely saved by the Depression. Although it lacked capital, the campus provided housing and food. In 1942, the Farm School merged with the Dorland-Bell School for Girls in Hot Springs, forming Warren Hugh Wilson Vocational Junior College. Wilson was a Presbyterian minister with a PhD in Sociology from Columbia University whose philosophy was that "the church was a social as well as a divine institution."

Built by the students and faculty, the log cabin chapel was dedicated on November 3, 1940, to Elizabeth Williams, a beloved teacher from 1895 to 1927. Until 1964, when the Warren Wilson Church was built, the log cabin chapel also served as the assembly hall and theater. Billy Edd Wheeler and Mary Bannerman were the last couple to marry in the chapel. Mary's father, Arthur Marling Bannerman, joined the faculty in 1928 and served as president from 1942 to 1971.

This real photo postcard of the Alexander farm captures Oliver M. "Spec" Alexander riding his pony in front of his uncle Charles H. Alexander's house. In 1956, Charles sold the 296-acre farm to Warren Wilson College for $79,000. (Bill Alexander.)

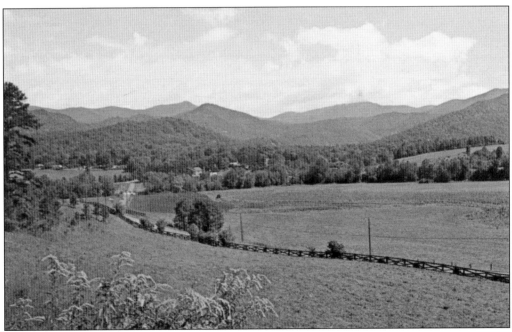

This view of the rolling farm on the campus was taken near the site of the Alexander farmhouse. In 1952, A. Lee Shippy, an African American resident of the Swannanoa Valley, was admitted. The following year, Georgia Powell of Augusta, Georgia, became the first African American female to attend. She graduated in 1955. Warren Wilson expanded to a four-year liberal arts college in 1967. Today, some 900 undergraduates work on the now-private college's 1,130-acre farm, managed forest, and campus as part of their graduation requirements.

The Swannanoa String Band was photographed at the Asheville Farm School in 1895, and the image was transformed into a quilt by Stefanie Wilds in 2013. The valley is noted for its musical heritage, including bluegrass pioneers Wiley and Zeke Morris; fiddler Marcus Martin; Black Mountain College musician John Cage; Billy Edd Wheeler, the composer of "Ring of Fire"; and Grammy Award winner Roberta Flack. (Don Talley and Stefanie Wilds.)

William Davidson, after avenging the death of his twin brother, Samuel, by a Cherokee hunting party in 1784, returned with fellow Presbyterian James Alexander and their families. They established the Swannanoa Settlement, the first European settlement in the valley, at the confluence of Bee Tree Creek and the Swannanoa River. Bee Tree Creek was dammed in 1927 to provide water for Asheville.

Thomas Lindsey, a photographer and travel writer in Asheville, captured images of the Swannanoa River in the 1890s. A photograph similar to the scene on this 1910 postcard was published in his 1890 Western North Carolina travel guide. Many postcards sent by tourists in the early 1900s featured the scenic Swannanoa River.

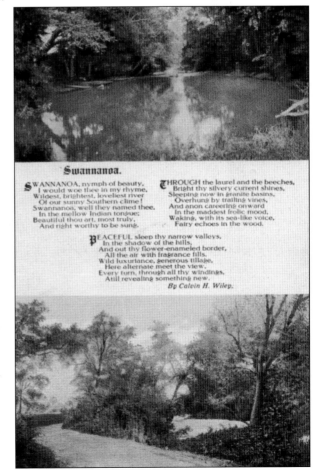

"Swannanoa" was one of the most popular poems in North Carolina prior to the Civil War. The name of the poet is disputed. Some attribute it to Dr. Daniel Harrison Jacques of Charleston, South Carolina, an early guest at Sherrill's Inn. However, in his 1851 book *North Carolina Reader*, Charles Wiley suggested the poem was written by an anonymous contributor to the *Asheville News*, where it was first published.

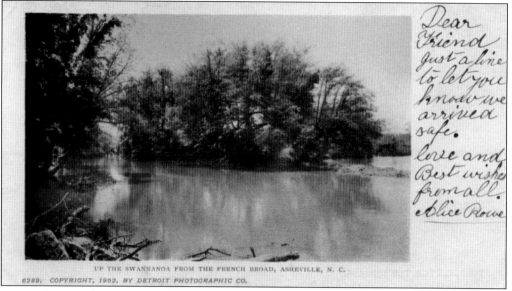

Many photographers came to capture the beauty of the Swannanoa. William Henry Jackson (1843–1942), a photographer and a member of the 1871 Hayden Geological Survey of Yellowstone and the Grand Tetons, captured pastoral scenes along the Swannanoa. Many of his photographs were produced as chromolithographs by the Detroit Publishing Company between 1895 and 1910 and were featured on postcards, including this 1902 postcard of the confluence of the Swannanoa and French Broad Rivers near Biltmore.

The Tanbark Overlook along the Blue Ridge Parkway offers an expansive view of the Riceville community, named for Joseph Miller Rice, who came from Tennessee and settled there in the 1780s. Granted the same property twice, once from the Shawnee and then from the State of North Carolina, which did not recognize the Shawnee claim, Rice operated a drover's station and hunted buffalo, which were seen in the valley until around 1800.

Seven

BEYOND GUDGER'S BRIDGE
OTEEN, AZALEA, AND BILTMORE

Samuel Davidson built his family's homestead along Christian Creek, not far from what is now the site of the Billy Graham Training Center at The Cove. While the Swannanoa Valley stretches geographically from the eastern continental divide at Ridgecrest to the confluence of the Swannanoa and French Broad Rivers at Biltmore, Gudger's Bridge, spanning the Swannanoa River on Highway 70, is considered by many to be the valley's cultural divide, with a more rural lifestyle to the east and a more urban lifestyle to the west.

Gudger's Bridge approximates the southeastern boundary of Asheville, which includes Oteen, Azalea, and Biltmore, all geographically part of the Swannanoa Valley. Oteen is home to the Charles George Veterans Affairs Medical Center, which was first established by the Army in World War I to meet the needs of servicemen suffering from tuberculosis. It now serves thousands of veterans each year. In 1937, Thomas Wolfe, an Asheville native and the author of the novel *Look Homeward, Angel*, among others, rented a cabin in Oteen, seeking a quiet location to continue his writing.

Traveling farther west, Biltmore Village was built along the Swannanoa River by George Washington Vanderbilt II to house the workers and their families needed to construct his 250-room manor home, the largest private home in the nation. George Vanderbilt died in 1914, at only age 51, due to complications from an appendectomy. His widow, Edith, sold 86,700 of the estate's 125,000 acres to the US government for $5 per acre, forming the nucleus of the Pisgah National Forest. A major tourist attraction, the manor house was opened to the public on March 15, 1930. His family home now opens its doors to one million guests each year.

Rev. Billy Graham, one of the Swannanoa Valley's best-known residents, received his call to the ministry on the 18th green while a student at the Bible Institute in Temple Terrace, Florida. This card, addressed to George Bird and Mary Alice Talbot of Swannanoa, shows Graham's 1958 crusade at the Coliseum in Charlotte. The Billy Graham Training Center at The Cove was established in 1987.

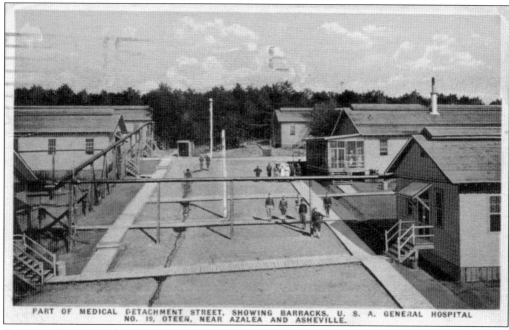

Oteen's USA General Hospital No. 19 was built by the Army in 1918 to treat 1,200 servicemen, many of them suffering from tuberculosis. According to a September 10, 1928, article in the *Asheville Times*, Col. Henry Hoagland suggested the name Oteen because it was an American Indian word meaning "chief aim," and it was "the chief aim of every patient to get well."

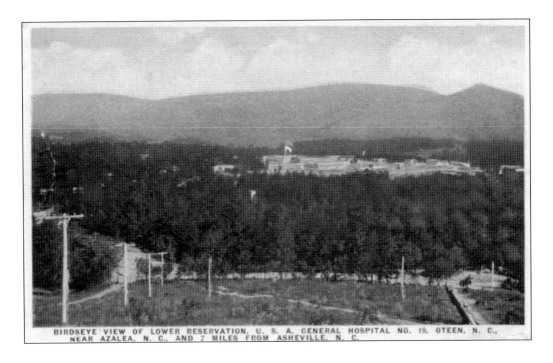

BIRDSEYE VIEW OF LOWER RESERVATION, U. S. A. GENERAL HOSPITAL NO. 19, OTEEN, N. C., NEAR AZALEA, N. C., AND 7 MILES FROM ASHEVILLE, N. C.

The writer of the postcard above, postmarked 1919, stated, "Having the time of my life supporting the soldiers." The Army's Oteen General Hospital was incorporated into the Veterans Bureau in 1922. Between 1924 and 1932, the Army's original well-ventilated, wooden buildings were replaced with permanent structures built in the Colonial and Georgian Revival styles. The same article quoting Colonel Hoagland was headlined "Oteen Growing Beautiful with New Buildings."

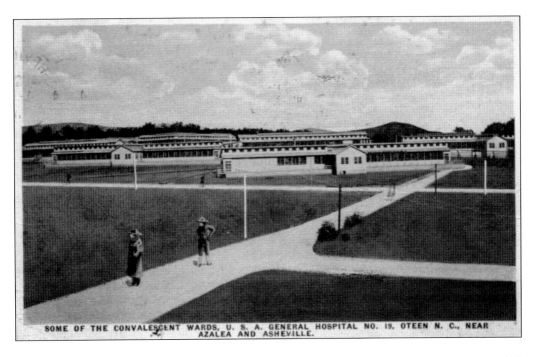

SOME OF THE CONVALESCENT WARDS, U. S. A. GENERAL HOSPITAL NO. 19, OTEEN N. C., NEAR AZALEA AND ASHEVILLE.

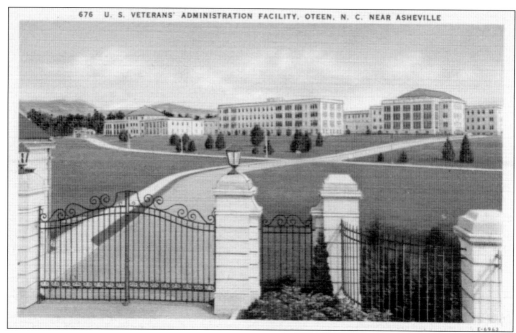

The namesake of Oteen's Charles George Veterans Affairs Medical Center was a member of the Bird Clan of the Cherokee Indian Tribe. Born on August 23, 1932, in Cherokee, North Carolina, he served in the Army during the Korean War. On November 30, 1952, at only 20 years old, he lost his life in combat while saving others. He was awarded the Medal of Honor.

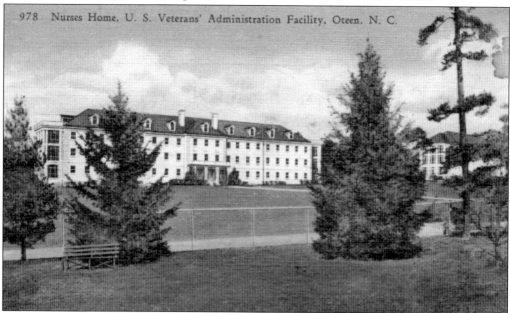

Housing needed for the administrative and medical staff was built along the northwest portion of the campus, seen here. In 1937, two dormitories, similar in size and structure, housed the nursing staff. The African American Nurses Dormitory was rebuilt by the State of North Carolina in 2012 to house its western archives department. The papers and photographs of Black Mountain College and the Blue Ridge Parkway are among its holdings.

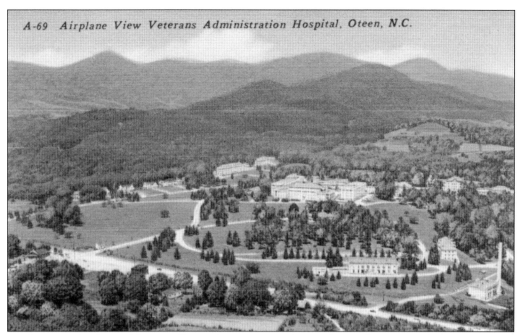

With a 2012 budget of $270 million, the expansive hospital complex serves thousands of area veterans with two outpatient clinics, a 119-bed facility in Oteen, and a 120-bed community living center in Swannanoa, on the former site of Moore General Hospital. Its mission is to fulfill Pres. Abraham Lincoln's Civil War promise: "To care for him who shall have borne the battle."

A dam was built was on the Swannanoa River near Azalea in the late 1800s to provide water for a nearby mill. After the flood of 1916, the spillway was closed and the 56-acre Lake Craig was created. In the 1950s, Lake Craig was drained. It is now the site of the John B. Lewis Soccer Complex and playground at Azalea Park.

The Asheville Recreation Park in Azalea was built along the river during the booming 1920s. The park offered boating on Lake Craig, dancing, golfing, a swimming pool, a zoo, and a Ferris wheel. It was highlighted in a period promotional booklet advertising to "Live and Invest in the Land of The Sky."

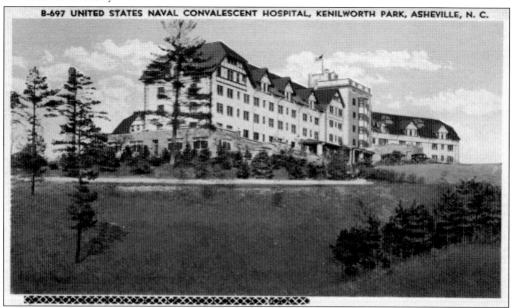

Built in 1918, the Kenilworth Inn could accommodate 500 guests. Before opening, it served as an Army hospital treating servicemen suffering from tuberculosis and civilian German internees from Hot Springs with typhoid fever. Open to guests only from 1923 to 1929, it sold for $1,200 after the 1929 stock market crash, becoming a mental health facility. Used by the Navy during World War II, it again reverted to a mental health facility before becoming an apartment complex in 1999.

This massive archway designed by Rafael Guastavino marks the entrance to the Biltmore Estate near the Swannanoa River. In the 1880s, George Vanderbilt visited Asheville with his mother, who suffered from malaria. A bachelor, he purchased 125,000 acres and built a 250-room manor house, the largest private home in America. It was completed in 1895 and opened to the public in 1930. Vanderbilt married Edith Stuyvesant Dresser in 1898.

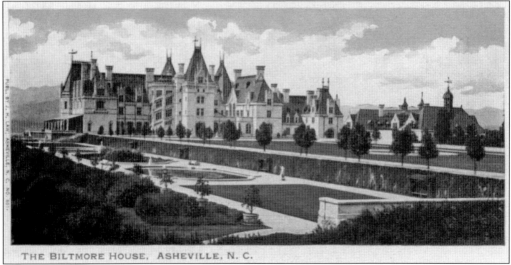

THE BILTMORE HOUSE, ASHEVILLE, N. C.

Richard Morris Hunt and Richard Sharp Smith were the architects of the manor house, seen here in 1908. Rafael Guastavino of Spain and Black Mountain designed the interior arched domes. Frederick Law Olmsted, the designer of New York City's Central Park, landscaped the grounds. The Biltmore School of Forestry, the country's first forestry school, operated on the estate from 1898 to 1909. On May 21, 1914, Edith Vanderbilt sold 86,700 of the estate's 125,000 acres, forming the core of the future Pisgah National Forest.

George Vanderbilt bought the village of Best in 1889, changed its name to Biltmore, and built houses, shops, and a church for his approximately 1,000 employees and their families. Best had been named for William J. Best, the president of the Western North Carolina Railroad in 1880. The name Biltmore is a combination of the family's ancestral home in Holland, Bildt, and the Anglo-Saxon "More," for rolling hills. The original Kenilworth Inn, seen in the upper right of this postcard, was built in 1890 and burned down on April 14, 1909.

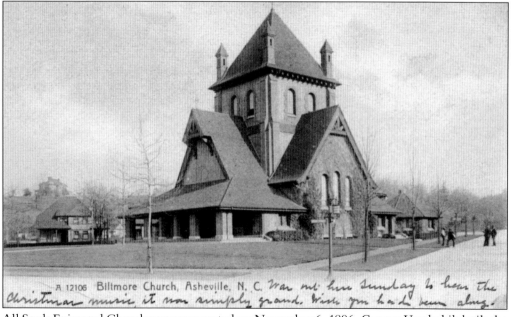

All Souls Episcopal Church was consecrated on November 6, 1896. George Vanderbilt built the church and was active in church life, serving as its senior warden until his death in 1914 at age 51. A 1908 visitor wrote, "Here Sunday to hear the Christmas music. It was simply grand." In 1995, All Souls was designated the first cathedral for the Diocese of Western North Carolina.

In the early 1900s, visitors to the Biltmore Estate traveling by rail could disembark at the Biltmore station, near the river. By one account, some 50,000 people a year were visiting Western North Carolina in the 1880s, with the number increasing to 250,000 per year by 1916.

Two hurricanes hit Western North Carolina in July 1916. On July 15 alone, 22 inches of rain fell at Altapass. Because of the extensive clear-cutting in the Swannanoa watershed, the runoff was devastating. The rivers flooded on July 16, destroying much of Biltmore and Asheville, although only two inches of rain fell in Asheville itself. Buried at North Fork's Methodist Tabernacle Church, sisters **Emma** and **Charlotte Walker** were among the dead. Their tombstone was paid for by Edith **Vanderbilt**.

At Carrier Park, near Biltmore, the Swannanoa flows into the French Broad River. The French Broad is the third-oldest river in the world, after the Nile and the New River. Flowing northward, the French Broad joins the Holston to form the Tennessee River, whose waters then fall west of the Blue Ridge and continue their journey to the Ohio and Mississippi Rivers before finally reaching the Gulf of Mexico.

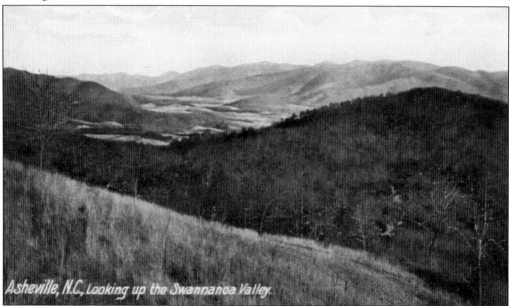

Like the river, this book has completed its journey westward through the Swannanoa Valley. This postcard, gazing back to the east, shows a vista unbroken by settlement in 1906. Many have now come to live and vacation within the shadows of the mountains, and thousands have hiked the mountain ridges, enjoying what is known as "Eastern America's Highest and Most Historic Skyline." We hope you have enjoyed your postcard journey. Sincerely, Mary and Joe.

Bibliography

Anderson, Robert Campbell. *The Story of Montreat from Its Beginning, 1897–1947.* Kingsport, TN: Kingsport Press, 1949.

Barnes, Kent A. *The Mountain, the Man, and the Dream: The Story of the Ridgecrest Conference Center.* Bloomington, IN: AuthorHouse, 2004.

Chesky Smith, Anne E. for the Swannanoa Valley Museum. Images of America: *Swannanoa.* Charleston, SC: Arcadia Publishing, 2013.

Goodson, Joan and Robert, eds. *On the North Fork of the Swannanoa River 1800–1950, Told by Contemporaries.* Black Mountain, NC: self-published, c. 1997.

Jensen, Henry W. *A History of Warren Wilson College on the Occasion of the College's Eightieth Anniversary.* Text by Henry W. Jensen; research by Elizabeth G. Martin. North Carolina: self-published, 1974.

Lovelace, Jeff. *Mount Mitchell, Its Railroad and Toll Road.* Johnson City, TN: Overmountain Press, 1994.

Middleton, Robert L. *A Dream Come True: A History of the Ridgecrest Baptist Assembly.* Nashville: Convention Press, 1957.

Parris, Joyce Justis. *A History of Black Mountain, North Carolina, and its People.* Black Mountain, NC: Black Mountain Centennial Commission, c. 1992.

Schwarzkopf, S. Kent. *A History of Mt. Mitchell and the Black Mountains: Exploration, Development, and Preservation.* Raleigh, NC: North Carolina Division of Archives and History, 1985.

Silver, Timothy. *Mount Mitchell and the Black Mountains: An Environmental History of the Highest Peaks in Eastern America.* Chapel Hill, NC: University of North Carolina Press, 2003.

Sondley, Forster Alexander. *A History of Buncombe County, North Carolina.* Asheville, NC: Advocate Printing, 1930.

Standaert, Mary McPhail, ed. *The Montreat Gateboys and Their Stories.* Montreat, NC: self published, 2012.

Standaert, Mary McPhail and Joseph Standaert. Postcard History Series: *Montreat.* Charleston, SC: Arcadia Publishing, 2009.

Swannanoa Valley Museum. Images of America: *Black Mountain and the Swannanoa Valley.* Charleston, SC: Arcadia Publishing, 2004.

Discover Thousands of Local History Books Featuring Millions of Vintage Images

Arcadia Publishing, the leading local history publisher in the United States, is committed to making history accessible and meaningful through publishing books that celebrate and preserve the heritage of America's people and places.

Find more books like this at
www.arcadiapublishing.com

Search for your hometown history, your old stomping grounds, and even your favorite sports team.

Consistent with our mission to preserve history on a local level, this book was printed in South Carolina on American-made paper and manufactured entirely in the United States. Products carrying the accredited Forest Stewardship Council (FSC) label are printed on 100 percent FSC-certified paper.